IMAGES
of America

CACTUS LEAGUE
SPRING TRAINING

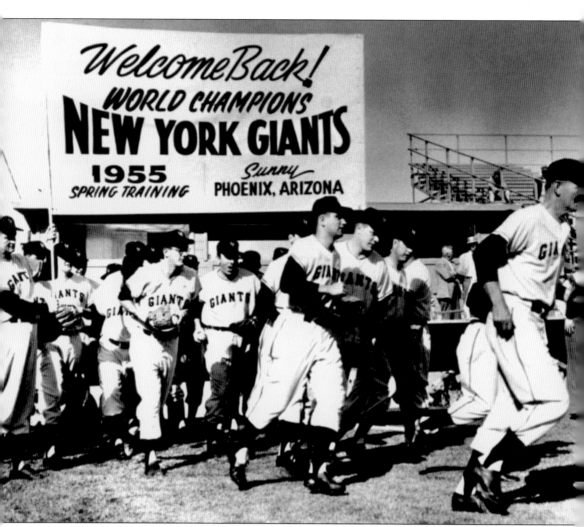

In 1954, the New York Giants won the World Series, sweeping the Cleveland Indians in four games. At the time, both teams were holding spring training in Arizona, making this the first all–Cactus League series. In 1955, the Giants were enthusiastically welcomed back to their spring training home at Phoenix Municipal Stadium. (Photograph by Phoenix Newspapers Inc.; courtesy of Mesa Historical Museum.)

ON THE COVER: Enthusiastic Chicago Cub Ernie Banks shows off the team's 1960 spring schedule painted on a fence at Mesa's Rendezvous Park. Dubbed "Mr. Cub" by fans, Banks played 18 of 19 spring training seasons in Arizona at Rendezvous Park and Scottsdale Stadium. During his career, Banks hit 512 home runs. (Courtesy of Trina Fitch Kamp, Mesa Historical Museum.)

IMAGES of America
CACTUS LEAGUE SPRING TRAINING

Susie Steckner and the
Mesa Historical Museum

Copyright © 2012 by Susie Steckner and the Mesa Historical Museum
ISBN 978-0-7385-8534-5

Published by Arcadia Publishing
Charleston, South Carolina

Printed in the United States of America

Library of Congress Control Number: 2011940759

For all general information, please contact Arcadia Publishing:
Telephone 843-853-2070
Fax 843-853-0044
E-mail sales@arcadiapublishing.com
For customer service and orders:
Toll-Free 1-888-313-2665

Visit us on the Internet at www.arcadiapublishing.com

To my dad, Bob Steckner, for taking me to spring training games and to Ted and Alice Sliger for their incomparable Cactus League collection.

Contents

Acknowledgments		6
Foreword		7
Introduction		8
1.	Play Ball Arizona	11
2.	Setting the Scene	41
3.	Buckhorn Baths	55
4.	Desert Star Power	73
5.	Who's on First	87
6.	Fan Club	111
7.	The Lineup	119
About the Organization		127

ACKNOWLEDGMENTS

This book would not be possible without the vast collection of memorabilia and photographs from the Mesa Historical Museum and its program Play Ball: The Cactus League Experience. For their expertise and encouragement, I would like to thank museum president and CEO Lisa Anderson, museum board vice president and Play Ball project leader Robert Johnson, and the late Robert Brinton, who was a museum board member and the president and CEO of the Mesa Convention and Visitors Bureau. Many others associated with the museum and Play Ball shared their knowledge and memorabilia, including museum board member Vic Linoff, Play Ball research coordinator Rodney Johnson, and Play Ball supporters Charlie Vascellaro and Tim Sheridan. Another Play Ball supporter, writer Mike Sakal, was very generous with his time and promoted this book early on. Play Ball donor Larry Ward provided one-of-a-kind photos and captions to go with them. The museum's Nicole Coldiron and Alice Jung provided never-ending assistance.

Aside from the museum's collection, this book includes images and historical background from dozens of people and organizations around Arizona and beyond. My sincere thanks goes out to Arizona Historical Society/Tucson (Jill McCleary), Arizona State University Libraries (Rob Spindler and Neil Millican), Bisbee Mining & Historical Museum (Annie Larkin and Carrie Gustavson), Charles Kapner, Coach House (James and Judiann Brower), City of Tempe (Kris Baxter), *Daily News-Sun* (Dan McCarthy and Steve Chernek), Francisco Grande Hotel & Golf Resort (Sue McFarlane and Michelle Ramirez), Gary Herron, Geoffrey Gonsher, Gov. Rose Mofford, Jim Bruner, Jim Painter, Jim Sutton, Joe and Ichiko Long, Houston Astros (Steve Grande), National Baseball Hall of Fame Library (John Horne), Pat Dean, Peter Welsh, Phoenix Municipal Stadium (James Vujs), Scottsdale Charros (Margaret Leichtfuss and Brigid Wright), Scottsdale Historical Museum (JoAnn Handley), Sue and Richard Burwell, Ted Sliger Jr., Tempe Historic Preservation Office (Joe Nucci), Tempe History Museum (Josh Roffler), *The Arizona Republic* (Donna Colletta and Randy Lovely), Todd Photographic Services (Jim Todd), and Trina Fitch Kamp.

My final thank-you goes to my husband, Chris Fiscus, my biggest supporter and best editor. Chris serves the museum as a board member and has been working to expand Play Ball. He convinced me to donate an item of my dad's to the museum, and I have been hooked on the project ever since.

Foreword

I first went to Phoenix for spring training in 1959. I was 20 years old and in the San Francisco Giants farm system. I was invited to come out by Horace Stoneham, the Giants' owner at the time.

Back then, the Giants played in the old ballpark by the cattle stockyards until the new Phoenix Municipal Stadium was built. The Giants were the first to get a new ballpark. We thought we were something else!

The Angels went to Palm Springs; the Padres went to Yuma. More clubs began coming to the desert for spring training after they found out what a great thing we had going. Today, 15 clubs have spring training in this beautiful area.

The Buckhorn Baths was a special place to me personally and to the Giants organization. My first visit was in 1965. Horace Stoneham invited a few players to stay at the baths for a week during spring training. I jumped at the chance to go there. All the players had their own little cottage. Behind the baths were hundreds of acres of desert where we would work out, do our running and throwing, practice plays, and just talk baseball. Every year I went there was special. Lasting friendships were made with bath owners Ted and Alice Sliger, their staff, and the players. One year, I took my dad; another year, my son Jack went with me.

Today, there is nothing better than spring training in Arizona! The atmosphere is electric. Players and fans are excited and eager to start the new season. The ballparks are great. Fans come to the games to see their favorite payers and the superstars and to watch the young kids coming up. Fans can watch their favorite teams play and get an idea of how the team might shape up. They can even talk to players and maybe get an autograph.

The Cactus League has a great history and a great future. I am proud to have been a part of the league for 17 years with the Giants, Indians, Padres, and Mariners. In all my 22 years in baseball, playing in the desert sun was an experience I cherish and never will forget.

—Gaylord Perry
National Baseball Hall of Fame pitcher, 1991

INTRODUCTION

When major-league teams the Cleveland Indians and New York Giants announced they would set up spring training camps in Arizona in 1947, Phoenix Chamber of Commerce chief Lewis Haas made a prophetic prediction to a news reporter, saying, "We think that other teams, which have in the past held their spring camps in Florida, will follow the lead of the Giants and Indians and come west, too." In 2011, Arizona would be hosting half of all major-league teams for spring training. Those 15 clubs would take over 10 stadiums, draw more than a million fans each spring, help drive the state economy, and boost the state's image in a way few other tourism efforts could. Spring baseball would find a place in history and in the hearts of communities around the state.

Major-league teams started traveling to Arizona for spring games more than a century ago. The Chicago White Stockings were the first in the early 1900s and paved the way for other clubs. The appeal of Arizona was easy to see. The state's near-perfect weather in the spring guaranteed plenty of playing time, and its proliferation of local teams offered more than enough competition.

City boosters, for their part, put out the welcome mats. After the Chicago White Sox made a stop in Mesa to play the local Mesa Jewels in 1914, White Sox team manager J.J. Callahan asked a reporter with the *Arizona Republican* newspaper to thank the city of Mesa "for the bully time given the ball players."

The turning point for spring training in the state came in 1946, when Cleveland Indians owner and part-time Tucson resident Bill Veeck Jr. announced that he wanted his team to train in Tucson. Veeck and Roy Drachman, a community leader and baseball advocate in Tucson, had previously discussed the merits of spring training in Arizona and agreed it would be a boon for the state.

"He [Veeck] wanted to see some weather charts, which I obtained for him, and we began talking seriously about trying to convince a couple of the teams to move into Arizona for their spring training," Drachman wrote in his autobiography *Just Memories*.

But Veeck needed a second team to join him in the state. Veeck knew New York Giants owner Horace Stoneham, who had a winter home in the Phoenix area, and he and Drachman went to see him with their plan, wrote Drachman.

Boosters with the Sunshine Climate Club in Tucson did not wait to see how things would play out. Along with Drachman and another baseball advocate, Hi Corbett, both of whom served on the city's baseball commission, plans got underway to improve the city's Randolph Park.

In 1946, Stoneham announced the club would trade Florida for Phoenix. It would set up camp at Phoenix Municipal Stadium, take over the Autopia Motel on Van Buren Street, and work out aches and pains at Mesa's Buckhorn Baths.

With two major-league teams established in the state, Mesa amped up its efforts to land a team. When the New York Yankees came to Phoenix to train for one year in 1951, Mesa's luck changed. Yankee owner Del Webb, an Arizona businessman, arranged for a meeting between community leader Dwight Patterson and Cubs officials. The club later announced it would set up camp in Mesa in 1952.

Veeck and Drachman would play another pivotal role in spring training when Veeck purchased the St. Louis Browns. Both men targeted Yuma as a training site for the team to expand the state's spring baseball hold. The Yuma Chamber of Commerce swung into action, according to *Baseball Digest* in 1953, "offering to pick up the St. Louis Browns' meal bill every day the sun doesn't shine on their new spring training diamond, so Bill Veeck is no doubt hoping for warm but cloudy weather."

Veeck ended up selling the team, which became the Baltimore Orioles. But the new owners decided to take a chance on Yuma for the 1954 season. With four teams in Arizona, the Cactus League was born.

Early on, booster clubs and civic groups took the lead in growing the Cactus League and promoting the state. It was a role they knew well. Long before the league, the groups had arranged for professional teams to play local teams and helped raise money to improve stadiums and build new ones. In those early days, booster groups included the Thunderbirds in Phoenix, the Sunshine Climate Club in Tucson, and the Mesa HoHoKams. The number would grow to include the Scottsdale Charros, the Tempe Diablos, and others. Baseball groups ultimately outgrew the "booster club" role, taking over critical game-day operations at stadiums.

Over the decades, the Cactus League had as many highs as it had lows. Teams came and went. Stadiums were built and torn down. Cities opted in and out. Attendance climbed up and down. Florida beckoned, and Arizona fought back. The league did not have a single defining moment; rather, it was built on stories big and small.

Among the bigger stories was the influx of teams in Arizona thanks to major-league expansions. There were five expansion teams—the Seattle Pilots, San Diego Padres, Houston Colt .45s, Seattle Mariners, and Colorado Rockies—that set up spring training camps in the state. A sixth team, the Los Angeles Angels, joined the Cactus League but split training time between California and Mesa. In 1995, Arizona was awarded its own expansion team, the Arizona Diamondbacks, which opened its spring training home in Tucson. Thanks to the flood of expansion teams, a handful of new cities joined the spring training rotation.

The Cactus League twice found itself in danger of extinction. The first time came after the 1965 season when the Boston Red Sox and Chicago Cubs decided to leave Arizona. That left just two teams—the Cleveland Indians and San Francisco Giants—training in the state. Arizona created a baseball commission to stabilize the league. The Cubs would soon return, followed by new teams. The fight was on.

The league was threatened again in the late 1980s when Cleveland set its sights on a move to Florida. Arizona officials worried that Florida could—and would—lure other teams with the promise of new stadiums. Then-governor Rose Mofford created a baseball task force to once again stabilize the league. The bottom line in this crisis was money to upgrade and build stadiums, and Arizona lawmakers came through.

Not surprisingly, stadiums were a big story for the Cactus League over the following two decades. The state saw a renovation-and-building boom and even started a trend with the first-ever spring training complex designed to host two teams.

A seminal moment for the Cactus League came when the Chicago White Sox left their spring training base in Florida for a new facility in Tucson. Arizona fans were used to teams doing the reverse. But the White Sox were just the start; a handful of teams, including the iconic Los Angeles Dodgers, would soon abandon Florida for Arizona. The Cleveland Indians, one of the original Cactus League teams, also returned to Arizona.

The league saw Salt River Fields at Talking Stick near Scottsdale, its 10th stadium, open for spring training in 2011. Home to the Arizona Diamondbacks and Colorado Rockies, the new facility was the top draw that season with an average of more than 10,000 fans per game. By 2013, Cubs fans expect the opening of the planned Wrigleyville West facility in Mesa.

The Cactus League and baseball fans everywhere lost a great man when Robert Brinton passed away suddenly in 2011. Brinton, past Cactus League president, was the driving force behind the effort to create Play Ball: The Cactus League Experience. So much of what has been accomplished to preserve, promote and present Arizona's amazing spring training baseball story is the result of his vision. Brinton hoped to one day have a permanent museum to house the Mesa Historical Museum's collection of unique spring training items and stories. He no longer is in the dugout with us, but we promise to finish this game for him and help establish a permanent Cactus League museum.

One

PLAY BALL ARIZONA

Arizona has played host to spring training baseball for more than a century, all the way back to 1909 when the Chicago White Stockings hopped off a train in Yuma. Though the state would not have an official "Cactus League" until 1954, the stage was set. Baseball would earn a place in the state's history books and become forever linked with local communities.

In the early 1900s, teams like the White Stockings and Pittsburgh Pirates barnstormed across the state looking for local competition to help hone their skills for the regular season. And when Phoenix built a new stadium to boost its profile, another team, the Detroit Tigers, took notice. In 1929, the Tigers became the first major-league team to officially hold spring training in the state.

Over the next two decades, spring training efforts stalled because of the Great Depression and World War II. But in the late 1940s, Arizona's baseball luck would change. On March 8, 1947, locals cheered a historic major-league matchup between the Cleveland Indians and New York (later San Francisco) Giants in Tucson. The Indians won 3-1, but Arizona enjoyed the bigger win.

The two teams officially set up camp in 1947 with the Indians at Randolph Park (later Hi Corbett Field) in Tucson and the Giants at Phoenix Municipal Stadium. Arizona saw another major-league team arrive in 1951 when the Giants traded camps with the New York Yankees for one year, a move that brought baseball superstars like Joe DiMaggio to the state. The following year, the Giants returned to Phoenix, and the Chicago Cubs arrived at their new spring training home in Mesa. Then in 1954, Yuma landed the Baltimore Orioles. At the time, Florida's venerable Grapefruit League had a firm grip on spring training. But with four teams playing at one time in sun-splashed Arizona, the Cactus League had arrived. A rivalry was born.

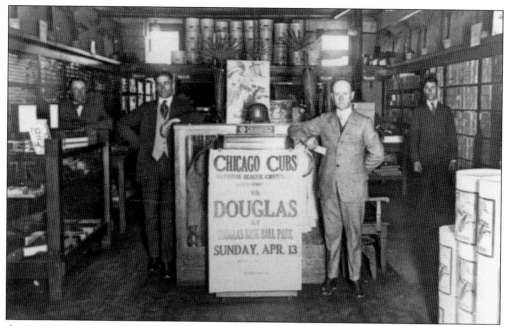

An upcoming spring exhibition game is the news of the day in this Arizona grocery store. A sign advertises a Chicago Cubs game in Douglas on April 13, 1919. The Cubs first visited Douglas and Bisbee in 1919 while barnstorming across the state; the Chicago White Sox and New York Giants visited the cities as well during a world tour in 1913. (Courtesy of City of Bisbee Collection, Bisbee Mining & Historical Museum.)

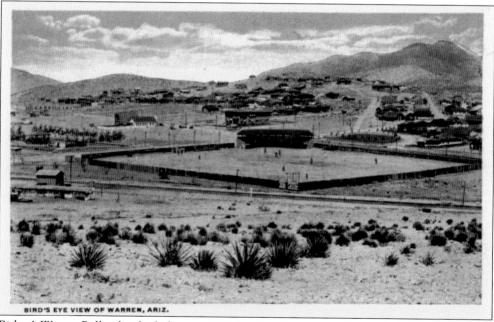

Bisbee's Warren Ballpark, which dates to 1909, has the distinction of being the oldest professional ballpark in the country. Over the decades, the park has hosted local teams, mining company teams, high school teams, semiprofessional teams, and major leaguers, including the Chicago Cubs. (Courtesy of Supanich Collection, Bisbee Mining & Historical Museum.)

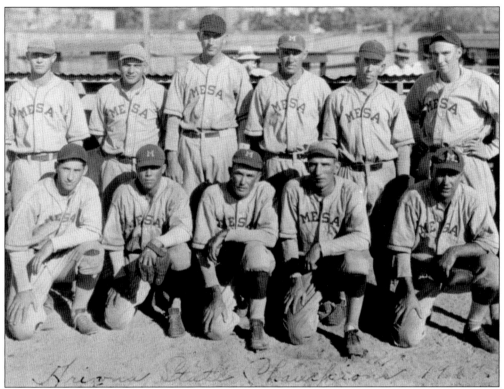

The Chicago White Sox were the first major-league team to play in Mesa, facing off against the local Mesa Jewels in 1914. Residents had raised a few hundred dollars to lure the Sox during a barnstorming trip, and the investment paid off. The game sealed a deal with the Sox, and the team regularly stopped in Mesa. (Courtesy of Trina Fitch Kamp, Mesa Historical Museum.)

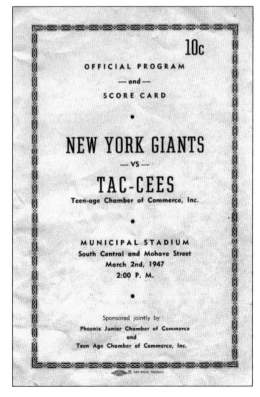

On March 2, 1947, the New York Giants played an exhibition game against the TAC-CEES (Teenage Chamber of Commerce) team at the original Phoenix Municipal Stadium at South Central Avenue and Mohave Street. An advertisement encouraged the teenage team: "Don't let those city slickers beat the pants off you. Get in there and pitch." (Courtesy of the Sutton family.)

Chicago Cubs players pose outside the Arizona Biltmore, a luxury hotel in Phoenix that opened in 1929. The Biltmore and Chicago Cubs were both owned by the Wrigley family, of the Wrigley chewing gum fortune, for decades. Cubs owner Philip Wrigley made the decision to set up spring training camp in Arizona. (Courtesy of Arizona Biltmore Photographs, Arizona Collection, Arizona State University Libraries.)

Cleveland Indians owner Bill Veeck Jr., who had a ranch in Tucson and wanted his team to train there, worked on Giants owner Horace Stoneham to move his team west too. In 1947, the Indians officially set up camp, and the club became the first Cactus League team to win a World Series in 1948. (Courtesy of National Baseball Hall of Fame Library.)

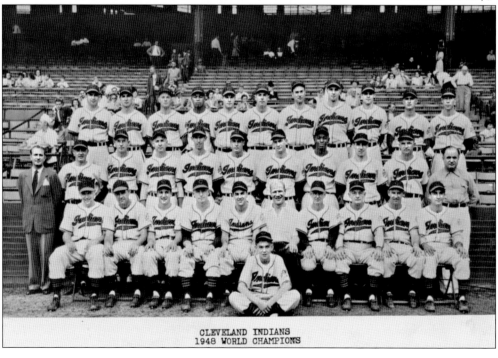

CLEVELAND INDIANS
1948 WORLD CHAMPIONS

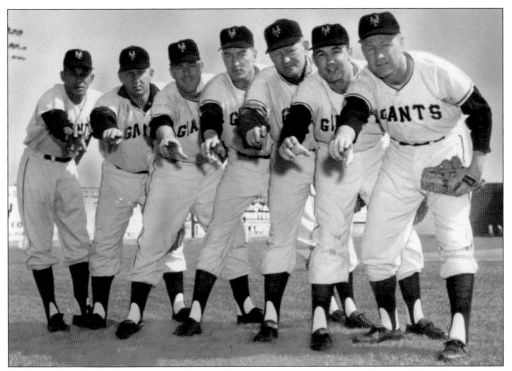

In 1946, New York Giants owner Horace Stoneham announced his club would trade its spring training camp in Florida for one at Phoenix Municipal Stadium. Stoneham told *The Arizona Republic* newspaper that he was wooed by the state's spring weather, but a hard sell by Cleveland Indians owner Bill Veeck and a cash deal from Phoenix played a part too. (Courtesy of National Baseball Hall of Fame Library.)

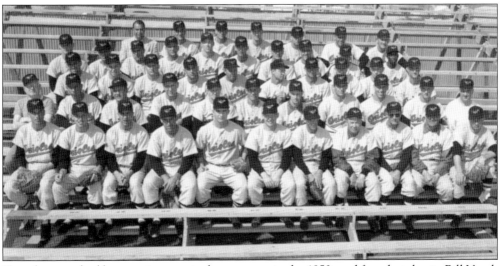

Yuma boosters had been eyeing a major-league team in the 1950s and found a taker in Bill Veeck Jr., owner of the St. Louis Browns. Veeck's Cleveland Indians were already training in Tucson, and the Yuma deal made good baseball sense. Veeck later sold the Browns, which then became the Baltimore Orioles. The Orioles landed in Yuma in 1954. (Courtesy of National Baseball Hall of Fame Library.)

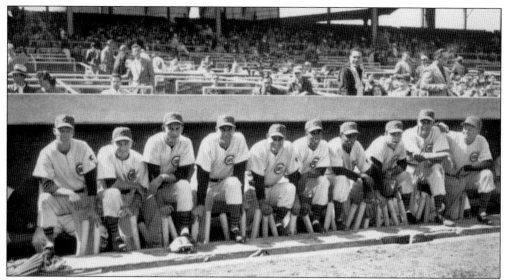

Mesa rancher and community leader Dwight Patterson helped lure the Chicago Cubs to Mesa's Rendezvous Park in 1952. Patterson noted that the Cubs dropped the team's isolated Catalina Island site in California because of less-than-ideal weather and scarce crowds. "It is hard to get anyone to play at Catalina," Patterson told *The Arizona Republic*. (Courtesy of National Baseball Hall of Fame Library.)

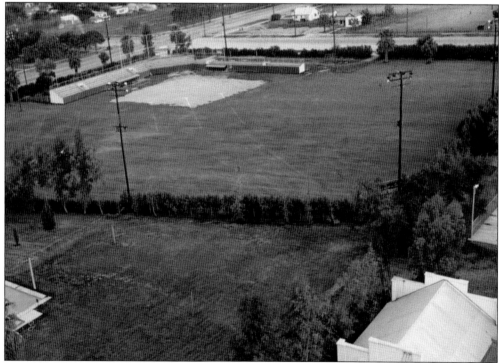

Mesa's first stadium was built in the early 1920s with wooden grandstands. It was part of a complex that eventually held a skating rink, pool, and dance hall. When the Mesa Chamber of Commerce held a contest to name the dance hall, choosing Rendezvous, newspapers began calling the stadium Rendezvous Park. (Courtesy of Mesa Historical Museum.)

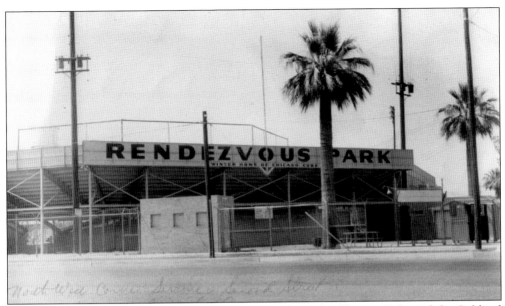

Mesa's popular Rendezvous Park (above) was home to both the Chicago Cubs and the Oakland Athletics. The park featured two water towers (below) that loomed over the stadium's outfield and were well-known markers for baseball fans. The stadium was razed in 1976 and replaced with the more modern Hohokam Stadium. (Above, courtesy of Mesa Historical Museum; below, photograph by Larry Ward, courtesy of Tim Sheridan and boysofspring.com, Mesa Historical Museum.)

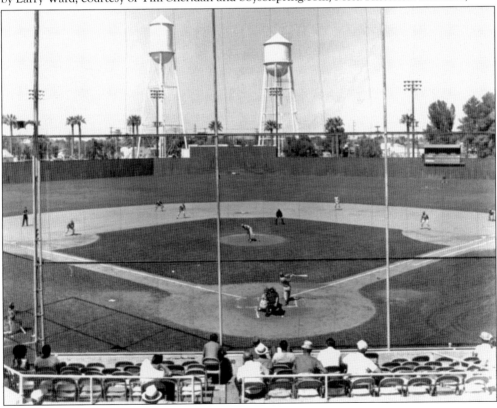

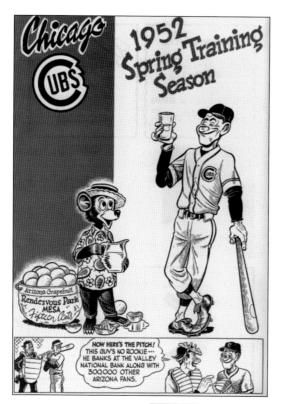

The Chicago Cubs program for the team's inaugural spring training season in Arizona in 1952 poked fun at Florida's Grapefruit League. A bear cub serves up juice made from grapefruits grown in Arizona, which was well known for its own citrus groves. The cub's shirt is covered with cacti and suns. (Courtesy of Ted and Alice Sliger, Mesa Historical Museum.)

In the early days of the Cactus League, fans at Mesa's Rendezvous Park regularly saw the New York Giants, Cleveland Indians, and Baltimore Orioles. Like other stadiums of the day, Rendezvous featured wooden fences and scoreboards changed by hand. The state's signature palm trees dotted the property. (Courtesy of Mesa Historical Museum.)

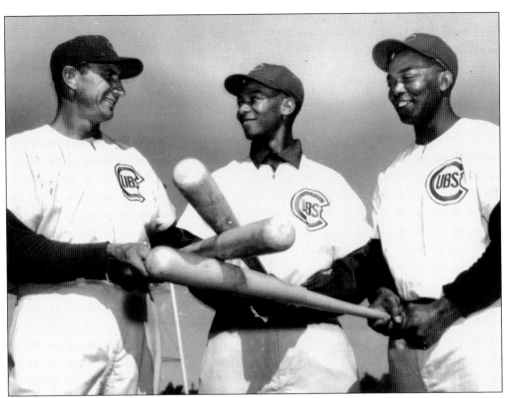

Chicago Cubs players (from left to right) Hank Sauer, Ernie Banks, and Monte Irvin pose for the camera at Mesa's Rendezvous Park on March 5, 1956. Banks would become a fixture in the spring in Arizona, spending his entire career with the Cubs. Sauer and Irvin were familiar faces locally too, as Irvin also played with the New York Giants and Sauer with the New York and later San Francisco Giants in Phoenix. (Courtesy of Robert Brinton, Mesa Historical Museum.)

This wallet-sized card shows the Chicago Cubs spring schedule for 1954. All four Cactus League teams are represented, as well as the St. Louis Cardinals. At the time, the Cardinals were training in St. Petersburg, Florida, but made an unusual trip west for a four-game series that included the Cubs. (Courtesy of Ted and Alice Sliger, Mesa Historical Museum.)

HOME SCHEDULE
In Mesa

Sat.—Mar. 6	Orioles
Wed.—Mar. 10	Giants
Tues.—Mar. 16	Cardinals
Wed.—Mar. 17	Indians
Fri.—Mar. 19	Orioles
Sat.—Mar. 20	Orioles
Wed.—Mar. 24	Indians

TRAVELING SCHEDULE
In Phoenix

Thurs.—Mar. 11	Giants
Thurs.—Mar. 18	Giants
Fri.—Mar. 23	Giants

In Yuma

Sun.—Mar. 7	Orioles
Fri.—Mar. 12	Orioles
Sun.—March 21	Orioles

In Tucson

Mon.—Mar. 8	Indians
Tues.—Mar. 9	Indians
Thurs.—Mar. 25	Indians

For All The News About The Cubs
Read The MESA TRIBUNE

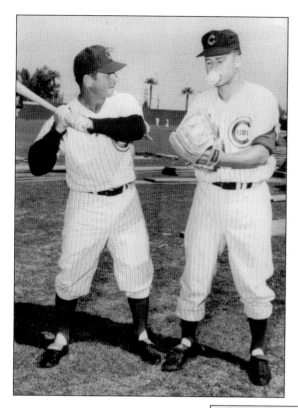

The Chicago Cubs became a favorite team in Arizona. Fans flocked to Mesa's Rendezvous Park each spring and would continue the tradition for decades to come. Ultimately, Cubs games at Mesa's Hohokam Stadium could easily draw more than 10,000 loyal fans per game. (Courtesy of Trina Fitch Kamp, Mesa Historical Museum.)

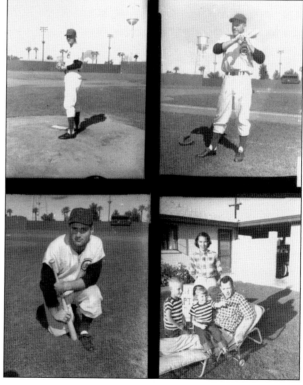

Chicago Cubs players were often photographed at work and at home. Clockwise from top left, pitcher Jim Brosnan stands ready on the mound, centerfielder Gale Wade prepares to take a swing for the camera, first baseman Dee Fondy relaxes at his Arizona home with his wife and children, and catcher Harry Chiti poses on the field. (Courtesy of Tim Sheridan and boysofspring.com, Mesa Historical Museum.)

The Chicago Cubs have been one of the Cactus League's mainstays over the past 60 years. But in 1966, the team opted to leave for a new camp in California. Community leader Dwight Patterson, who had helped bring the team to Mesa, was at a loss over the team's departure, saying, "I still can't believe it's spring training and the Cubs won't be back. It's like a bad dream." The Cubs could not stay away long though, returning to Scottsdale Stadium in 1967 and then to Mesa's Hohokam Stadium in 1979. (Courtesy of Richard and Sue Burwell.)

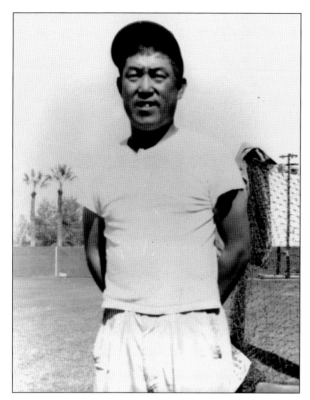

Yosh Kawano served the Chicago Cubs for 65 years and was known for his trademark white fisherman hat, khakis, and white T-shirt, as seen here at Rendezvous Park in Mesa. Kawano joined the Cubs in 1943 as a Wrigley Field clubhouse attendant and was named home clubhouse manager, emeritus in 2000. He retired in 2008. (Courtesy of Trina Fitch Kamp, Mesa Historical Museum.)

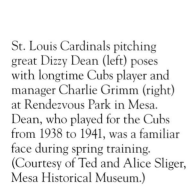

St. Louis Cardinals pitching great Dizzy Dean (left) poses with longtime Cubs player and manager Charlie Grimm (right) at Rendezvous Park in Mesa. Dean, who played for the Cubs from 1938 to 1941, was a familiar face during spring training. (Courtesy of Ted and Alice Sliger, Mesa Historical Museum.)

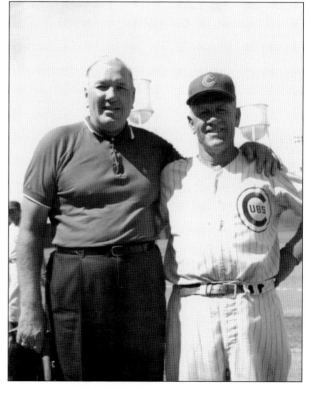

In 1952, the New York Giants returned to spring training camp in Phoenix with a new title—National League Champions—following the team's famous three-game playoff against the Brooklyn Dodgers in which Giant Bobby Thomson's game-winning home run became known as the "Shot Heard 'Round the World." The Giants also returned to a new spring training competitor in the Chicago Cubs. By 1954, the Giants and three other teams—the Cleveland Indians, Chicago Cubs, and Baltimore Orioles—were officially the Cactus League. (Both, courtesy of Ted and Alice Sliger, Mesa Historical Museum.)

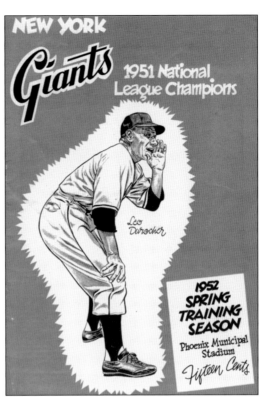

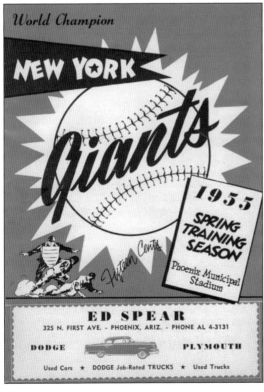

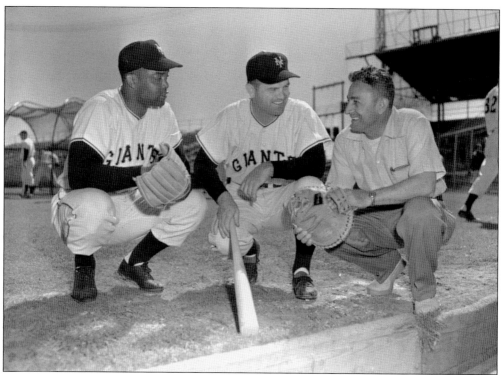

The New York (later San Francisco) Giants called Phoenix Municipal Stadium its spring training home from 1947 to 1981 with the exception of 1951 when the team trained in Florida. Even when Giants owner Horace Stoneham built a new training facility in Casa Grande, the team continued to play games at Phoenix Municipal Stadium. The team ultimately opted to move to Scottsdale Stadium for the 1982 season. Below, players pose for photographers at Phoenix Municipal Stadium in the mid-1950s. (Both photographs by Herb and Dorothy McLaughlin; courtesy of Arizona State University Libraries.)

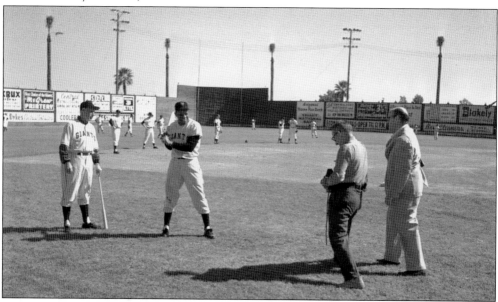

The *Phoenix Gazette* newspaper supported the New York Giants with wallet-sized cards (right and below) featuring a towering, muscle-bound saguaro cactus. The cards show the team's 1955 spring training schedule, which included a matchup with the All Stars of the minor-league Pacific Coast League (PCL). The reverse side of the card lists the Giants roster that year, which was filled with future stars and hall of famers like manager Leo Durocher, Willie Mays, and Monte Irvin. (Both, courtesy of Ted and Alice Sliger, Mesa Historical Museum.)

1955 Schedule of Spring Exhibition Games for the WORLD CHAMPION NEW YORK GIANTS

« « » »

Phoenix Municipal Stadium

Friday, March 11
Cleveland Indians

Sunday, March 13
Cleveland Indians

Monday, March 14
Chicago Cubs

Tuesday, March 15
Cleveland Indians

Wednesday, March 16
Chicago Cubs

Monday, March 21
Cleveland Indians

Thursday, March 24
PCL All-Stars

Friday, March 25
Chicago Cubs

Sunday, March 27
Chicago Cubs

Monday, March 28
Chicago Cubs

Courtesy of
The Phoenix Gazette

NEW YORK GIANTS 1955 Spring Training Roster and Numbers

1. Frank Shellenback, Coach
2. Leo Durocher, Manager
4. Herman Franks, Coach
5. Eric Rodin, of.
6. Fred Fitzsimmons, Coach
7. Mickey Grasso, c.
8. Ray Katt, c.
9. Wes Westrum, c.
10. Dave Williams, 2b.
12. Joe Amalfitano, 3b.
14. Bob Hofman, if.
15. Bill Gardner, if.
16. Henry Thompson, 3b.
17. Ronnie Samford, if.
18. Foster Castleman, if.
19. Alvin Dark, ss.
20. Monte Irvin, lf.
21. Jim Hearn, p.
22. Don Mueller, rf.
23. Bill Rigney, Coach
24. Willie Mays, cf.
25. Whitey Lockman, 1b.
26. Dusty Rhodes, of.
27. Bill Taylor, of.
28. Ruben Gomez, p.
29. Jack Lewis, of.
30. George Spencer, of.
31. Paul Giel, p.
32. Eddie Bressoud, if.
33. Allan Worthington, p.
34. Al Corwin, p.
35. Sal Maglie, p.
36. Bob Lennon, of.
37. Don Liddle, p.
38. Pete Burnside, p.
39. Jim Constable, p.
40. John McCall, p.
41. Ramon Monzant, p.
42. Marv Grissom, p.
43. John Antonelli, p.
44. Bill Hatcher, c.
45. John Spreen, c.
46. Larry Jansen, p.
47. Gail Harris, 1b.
48. Joe Margoneri, p.
49. Hoyt Wilhelm, p.
50. Ray Charles, c.
51. Chuck Pearson, c.

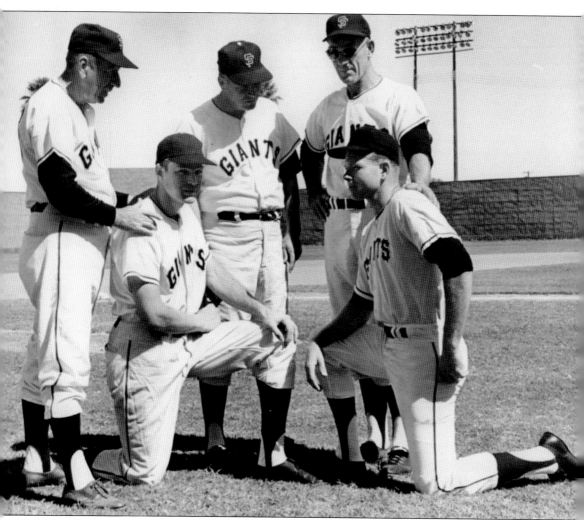

San Francisco Giants representatives and minor-league players pose at Phoenix Municipal Stadium in 1961. From left to right are (first row, kneeling) minor leaguers Arlo Engel and Jerry Robinson; (second row, standing) unidentified, minor-league manager Charlie Fox, and scout Gene Thompson. Major-league teams have long scouted for talent and honed young players' skills in the Arizona desert. (Courtesy of Ted and Alice Sliger, Mesa Historical Museum.)

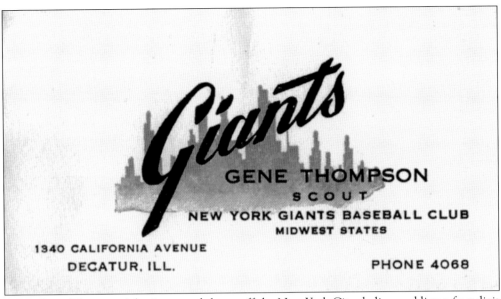

Scout Gene Thompson's business card shows off the New York City skyline and lists a four-digit phone number. Thompson, a former major-league pitcher, was a longtime scout for the team and a regular during spring training. (Courtesy of Ted and Alice Sliger, Mesa Historical Museum.)

NAME IN FULL					POS.	
	LAST NAME	FIRST NAME	MIDDLE NAME	HOME TEL. NO.		
ADDRESS						
	STREET NAME AND NUMBER	CITY OR TOWN	STATE			
SIGNED TO 19	CONTRACT	SALARY $		CLUB		
DATE OF BIRTH		HGT.	WGT.	THROWS		BATS
ARM	FIELDING		SPEED	BATTING		
PL. STRENGTH						
PL. WEAKNESS						
RECOMMENDED ACTION						
PROSPECT				DRAFT CLASS		
AGGRESSIVE		DISPOSITION				
HEALTH				MARRIED		
REPORTED BY				DATE		
PLACE OF BIRTH				SOCIAL SECURITY NO.		
WHEN WILL YOU REPORT?		WHEN WILL YOU GRADUATE FROM HIGH SCHOOL?				
				ADDITIONAL INFORMATION OVER		

A scouting "report card" from Thompson has space for a player's strength and weakness, military draft class, marital status, and expected date of high school graduation. (Courtesy of Ted and Alice Sliger, Mesa Historical Museum.)

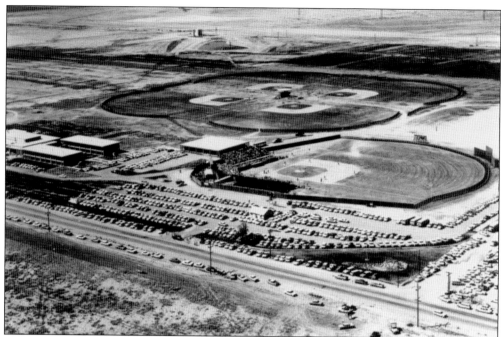

San Francisco Giants owner Horace Stoneham built his team a new spring training facility in Casa Grande called the Francisco Grande (above). The sprawling resort featured four training fields and a stadium. National League president Warren Giles attended the dedication before the first exhibition game in 1961. According to the resort, "Optimism swirled like desert dust devils when Willie Mays hit a 375-foot home run off Gaylord Perry in the fourth inning of the first-ever game at Francisco Grande." Stoneham (below, right) predicted that the resort would become a hit during the off-season too, but his hopes were dashed when plans for a proposed highway near the Francisco Grande changed and traffic bypassed the resort. (Both, courtesy of Francisco Grande Hotel & Golf Resort.)

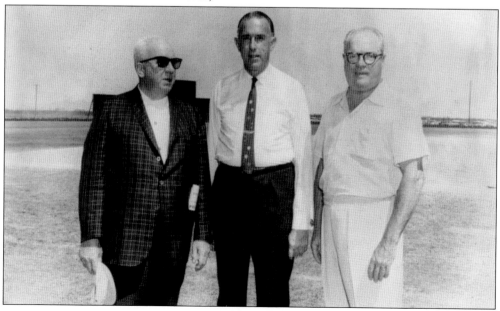

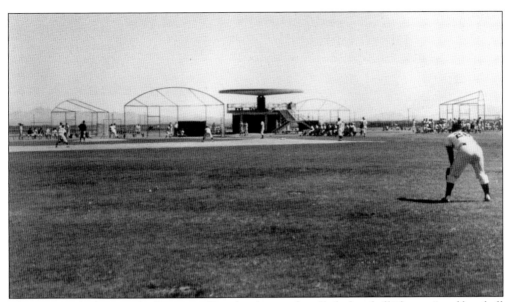

The training facilities at the Francisco Grande, alternately called a baseball "factory" and baseball "plant," included a unique observation deck in the center of four practice fields. The round, two-story structure gave coaches and members of the press a birds-eye view of the players during practices. Baseball greats and future hall of famers Willie Mays, Willie McCovey, and Juan Marichal honed their skills on the fields. The Francisco Grande resort also featured a modern-day stadium for exhibition games. The original observation deck and faded imprints of the old training fields can still be found at the resort. (Both, courtesy of Francisco Grande Hotel & Golf Resort.)

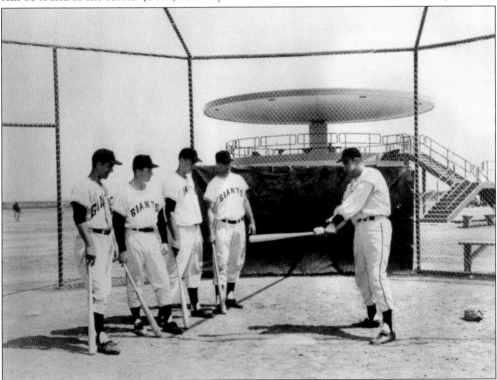

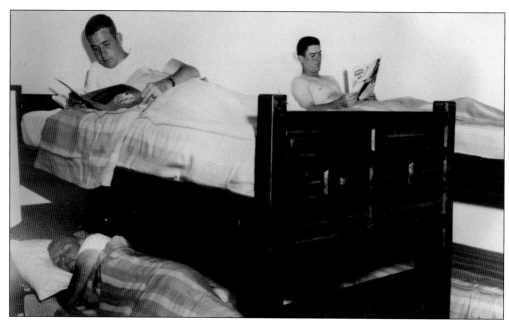

A 1965 feature on the Francisco Grande resort in *Pinal Ways* magazine described the players' living quarters as "the last word in plush accommodations. . . . The individual rooms are tastefully furnished in heavy mesquite wood patterned after early-day Spanish motif. The predominant colors of the furnishings are black and orange, the colors of the Giants team. Each room opens onto a veranda fronted by an ornamental iron railing. Large picture windows, shaded by decorative painted shutters, provide a view of the training fields and stadium." As part of daily life, players relax in bunk beds (above) and line up at the resort's dining room at mealtime (below). (Both, courtesy of Francisco Grande Hotel & Golf Resort.)

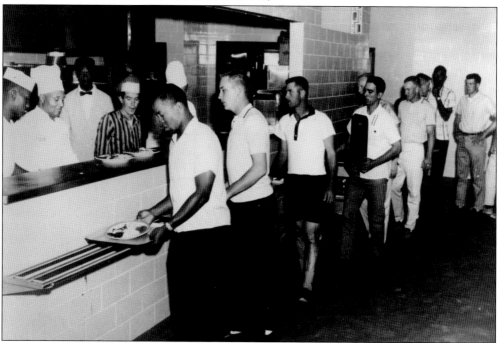

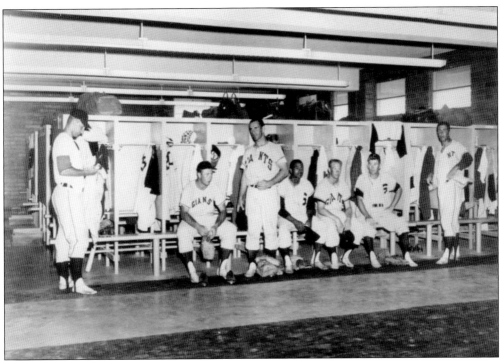

The clubhouse at the Francisco Grande was tops, according to a 1965 feature in *Pinal Ways*. "It houses four separate dressing rooms, each with its own showers and lavatories; training rooms and dressing rooms for umpires." Today, budget-minded travelers can stay in the players' former living quarters, while the locker rooms are used for laundry and storage. (Courtesy of Francisco Grande Hotel & Golf Resort.)

A 1966 schedule for the Phoenix Giants, the Giants' minor-league team, promoted the "beautiful" Francisco Grande resort. Fans could purchase a general admission ticket for just $1.50 or a spot on the pavilion for $1. A box-seat splurge set fans back $2. (Courtesy of Ted and Alice Sliger, Mesa Historical Museum.)

Phoenix Giants

Ticket Information

Season Box Seats $125.00 per seat
General Admission Books $10.00 (8 General Admissions — Save $2.00 per Book)

Daily Prices

Box Seats$2.00
General Admission$1.50
Pavillion$1.00
Service Men and College Students$1.00
High School and Children Admission ..$.50
Ladies Admission (On Ladies Nite) ...$.50
Service Charge Passes$.50
Special Group Rates (200 or more)

For Further Information
Write or Call Your
Phoenix Giants Baseball Club
Temporary until March 15 — 258-2997
After March 15 — 275-4488
5999 East Van Buren Phoenix, Arizona

See beautiful
**Francisco Grande Hotel
& Motor Inn**
Casa Grande, Arizona
Write or Call
P. O. Box F.F. (602) 836-8711

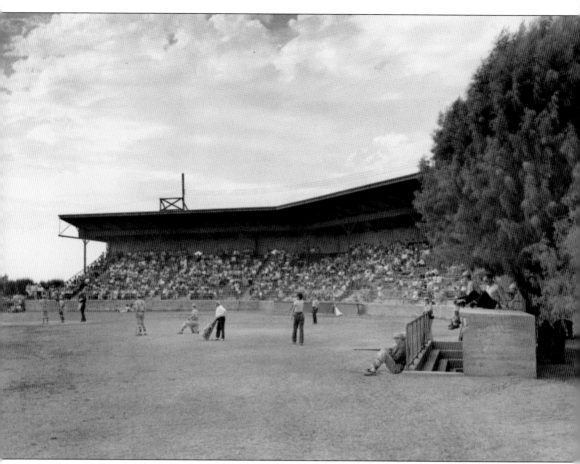

Tucson's Randolph Park was built in the 1930s and renamed Hi Corbett Field in honor of Hiram Corbett, a state senator and baseball booster who helped bring the Cleveland Indians to Tucson for spring training in 1947. Hi Corbett, as fans call the stadium, has the distinction of being the state's oldest spring training stadium that is still standing. It hosted the Indians until the team moved to Florida for the 1993 season. The expansion Colorado Rockies moved into Hi Corbett and trained there until the club's last game in 2010. The Rockies departed for the league's newest stadium near Scottsdale for the 2011 season. The move has left Hi Corbett without a major-league tenant. (Courtesy of Arizona Historical Society/Tucson.)

Pitching legend Bob Feller spent his entire 18-year career with the Cleveland Indians and was a fan favorite during spring training at Tucson's Hi Corbett Field. During his career, Feller amassed 266 victories and 2,581 strikeouts and led the league in strikeouts seven times. He was inducted into the National Baseball Hall of Fame in 1962. (Courtesy of Bob Feller Museum.)

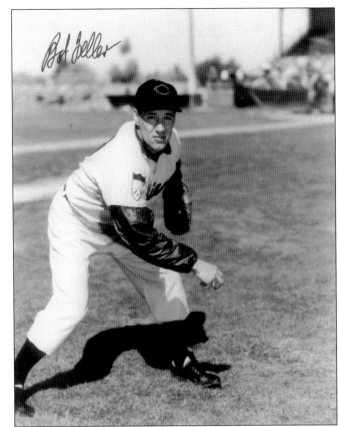

Off the field, Indians players could be found in the stadium's locker room, as shown in this 1968 photograph. The Indians' move to Florida in the 1990s ended an era for fans, as the club was one of the original Cactus League teams to train in Arizona. (Courtesy of Arizona Historical Society/Tucson.)

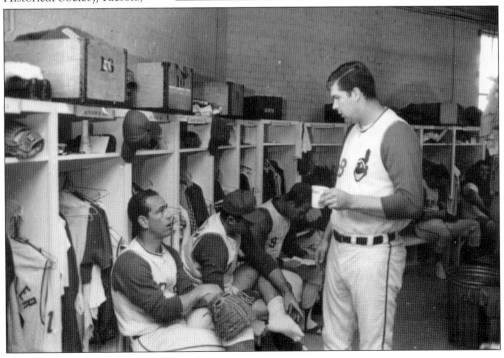

Scottsdale boosters pushed for a baseball stadium to attract a major-league team for spring training, and the city snagged the Baltimore Orioles. In November 1955, an advertisement in the *Arizonian* newspaper invited the public to an "inspection party" at the new Scottsdale Stadium. The event was deemed "one of the Valley's most momentous sports occasions." The party drew 10,000 spectators for a glimpse of the stadium plus a few stars. Jim Wilson, of the Orioles, pitched to Chicago Cub Hank Sauer and Cincinnati Red Ted Kluszewski. According to a story about the party, "The weather was perfect and the field matched any major league diamond at its best." (Courtesy of Scottsdale Historical Museum.)

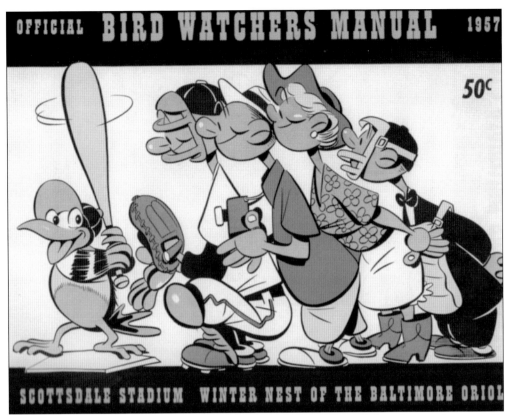

Business boosters raised $72,000 for the new Scottsdale Stadium, and local residents enthusiastically embraced baseball when the stadium opened for its first spring training season in 1956 with the Baltimore Orioles. This 1957 baseball program (above) is dubbed the "Official Bird Watchers Manual." Volunteers in the 1950s photograph below wear matching aprons and serve up coffee to fans. Scottsdale would go on to host the most teams in the Cactus League, including the Boston Red Sox, Chicago Cubs, Oakland Athletics, and San Francisco Giants. (Above, courtesy of Ted and Alice Sliger, Mesa Historical Museum; below, courtesy of Scottsdale Charros.)

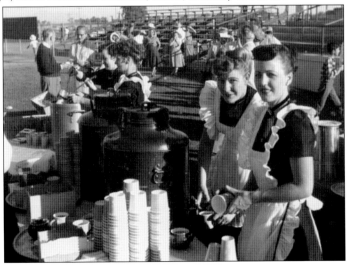

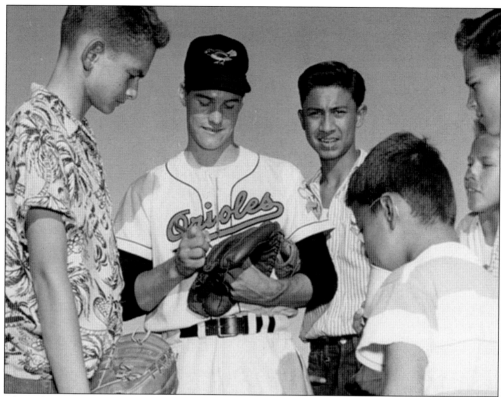

The Baltimore Orioles made two appearances in Arizona for spring training. The team bounced from Yuma to Florida to Scottsdale Stadium, then back to Florida. While the Orioles were in Scottsdale, the stadium was dubbed the team's "winter nest," and the team stayed in the city through the 1958 season. In the 1950s photograph above, an unidentified Orioles player happily signs a glove. The original Orioles bird rendering on the player's cap would remain part of the uniform for the team's first nine seasons. In another 1950s photograph (below), former major-league pitcher Lum Harris, an Orioles coach and later manager, signs autographs for fans in the stadium. (Both, courtesy of Scottsdale Charros.)

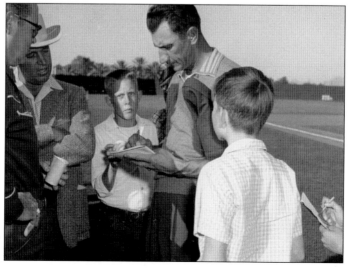

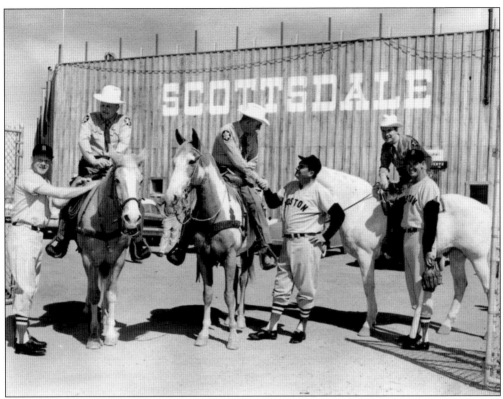

The Boston Red Sox set up spring training operations at Scottsdale Stadium in 1959. In true Arizona fashion, a sheriff's posse poses outside the stadium and greets, from left to right, Jackie Jensen, manager Mike Higgins, and legend Ted Williams. (Photograph by Boston Traveler; courtesy of Boston Herald and Scottsdale Historical Museum.)

With the Boston Red Sox training in Arizona, fans delighted in seeing veteran Ted Williams on the field. But they did not get to see the "Splendid Splinter" play very long, as Williams retired in 1960. Williams (right) was photographed at Scottsdale Stadium with hall of famer Ty Cobb. (Courtesy of Charlie Briley, Charlie Vascellaro.)

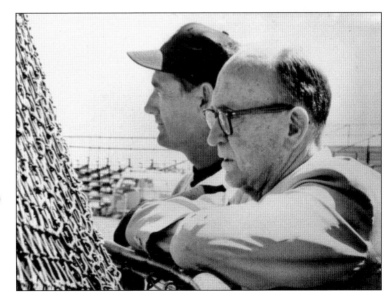

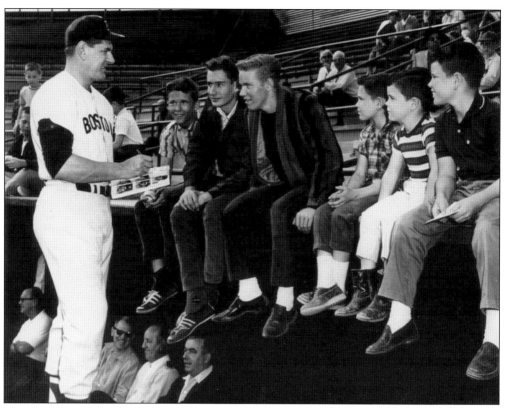

The Boston Red Sox called Scottsdale Stadium its spring training home until 1965 when the team moved to Florida. Unlike other major-league teams, the Red Sox would never return to Arizona and the Cactus League. In this 1950s photograph, a Red Sox player signs autographs for young fans in Scottsdale. (Courtesy of Robert Johnson, Mesa Historical Museum.)

In this 1964 photograph, Scottsdale mayor Bill Clayton poses with members of the Scottsdale Charros baseball booster group. The city of Scottsdale took over the deed to Scottsdale Stadium and agreed to maintain the facility. But the Charros organization was given the responsibility of staffing and managing the stadium. (Courtesy of Scottsdale Charros.)

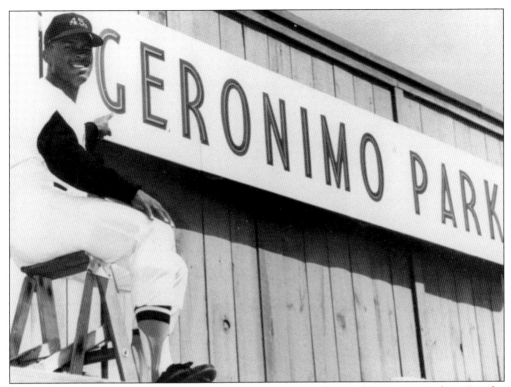

Manny Mota, a rookie with the Houston Colt .45s, poses in front of Geronimo Park in Apache Junction. The club's arrival brought the Cactus League to six teams. But the Colt .45s saw lukewarm community support and low attendance, which forced the club to leave Arizona in 1963. (Courtesy of Houston Astros.)

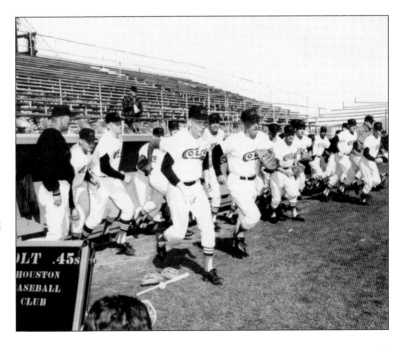

The national-league-expansion Houston Colt .45s (later Houston Astros) set up spring training camp in Apache Junction for the 1962 season. Located in a scenic desert setting near the Superstition Mountains, the team's training base was remote. A legendary story would be repeated about pitcher Turk Farrell shooting rattlesnakes as he crossed the desert toward the stadium. (Courtesy of Houston Astros.)

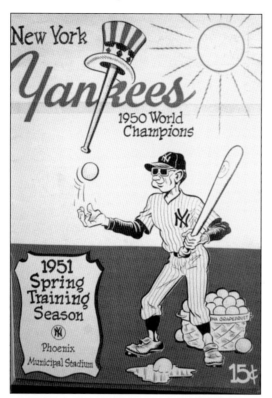

In 1951, the New York Giants and New York Yankees traded spring training sites for one season. The move gave Yankees owner and Arizona businessman Del Webb the opportunity to see his team train at home at Phoenix Municipal Stadium and fans the chance to cheer on names like DiMaggio, Mantle, and Berra. That same year, the Giants and Yankees would face off in the World Series. (Courtesy of Robert Brinton, Mesa Historical Museum.)

The New York Yankees' move to Phoenix for spring training brought the club's colorful manager Casey Stengel. This undated photograph shows Stengel (left), Yankees owner Del Webb (center), and an unidentified man. (Courtesy of Del Webb.)

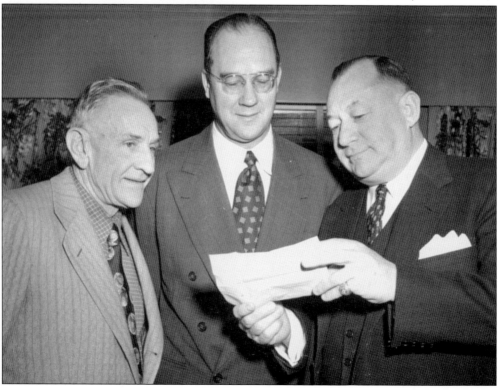

Two

SETTING THE SCENE

Over the decades, it seemed nothing could escape spring training fever: watering holes drew baseball stars and fans alike, western wear stores hawked cowboy boots to tourists, resorts lured East Coast fans to the sun-drenched state, and merchants threw Main Street parades for beloved teams. Anything was fair game, including the baseball-bat-shaped swimming pool and the mighty saguaro cactus "dressed" in a player's uniform.

Not surprisingly, state boosters led the charge and touted spring training as a top attraction to fill resorts, restaurants, shops, and stadium seats. For baseball fans from cold-weather states like New York and Boston, the pitch was easy: Come for "shirt-sleeve fun in the sun."

Mesa's Buckhorn Baths was among the more notable spring training spots early in Cactus League history. New York Giants owner Horace Stoneham believed the relaxing mineral baths and regular massages could get players in top form for the regular season. Stoneham would later build his own resort—the Francisco Grande in Casa Grande. The desert hideaway boasted four training fields and architectural gems like a baseball-shaped hot tub. Buckhorn Baths and the Francisco Grande became two of the stars in the state's tourism constellation. But they were not alone. The Pink Pony, a downtown Scottsdale bar and restaurant, also played a key role in the spring training scene for decades. The Pony became the hangout for not only baseball stars, scouts, and team executives, but also for tourists and fans. Other restaurants and bars became popular spots—notably Don & Charlie's and Coach House in Scottsdale, and Harry & Steve's in Mesa—but the Pony held court as the original.

Soon, it became clear that spring training was bigger than just baseball; spring training was helping to introduce Arizona to the world. Out-of-town journalists wrote stories and captured photographs from Phoenix, Mesa, Tucson, and elsewhere, helping mold the state's image. And it did not hurt to have Ted Williams spotted at the Hotel Valley Ho in Scottsdale or Willie Mays hitting the links on an Arizona golf course. Thanks to baseball, Arizona's national image soon was on the rise.

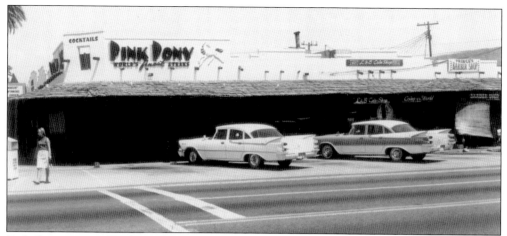

Pink Pony owners Charlie and Gwen Briley turned their downtown Scottsdale restaurant into a must-see destination. A part of the spring training scene for 60-plus years, the Pink Pony was praised as "the best baseball restaurant in the land" by The New Yorker and "the most popular hangout for baseball people in the civilized world" by Sports Illustrated. (Courtesy of Scottsdale Historical Museum.)

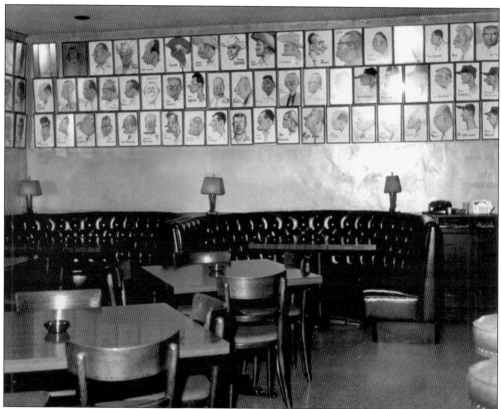

The Pink Pony was famously filled with baseball memorabilia. Among the more eye-catching was a series of cartoon caricatures by actor and artist Don Barclay, who captured images of baseball players and personalities. Though Barclay's movie credits included hits like Mary Poppins, his unique caricatures are what won high praise at the Pony. (Courtesy of Scottsdale Historical Museum.)

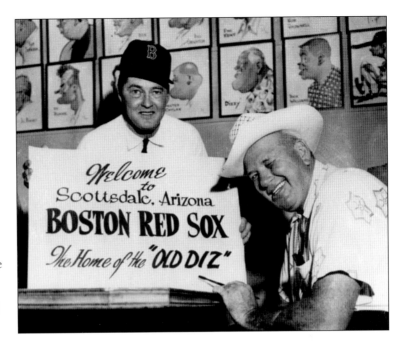

Pink Pony owner Charlie Briley (left) befriended St. Louis Cardinals pitching great Dizzy Dean (right), who was a regular at the Pony and helped attract other baseball stars. Briley was among a group of local businessmen in Scottsdale who raised money to build a wooden baseball stadium to attract Major League Baseball to the city. (Courtesy of Mesa Historical Museum.)

Drawing on the city's ranching past, the Scottsdale Chamber of Commerce anointed Scottsdale the "West's Most Western Town." But boosters used this larger-than-life cowboy sign to promote its future: spring training baseball at Scottsdale Stadium. This 1957 photograph shows the Baltimore Orioles' busy spring training schedule. (Courtesy of Ted and Alice Sliger, Mesa Historical Museum.)

Shown in the dugout at Scottsdale Stadium during the 1950s, the Scottsdale Baseball Club dons cowboy hats and handkerchiefs to promote the city's western theme for locals and out-of-town visitors. (Courtesy of Scottsdale Charros.)

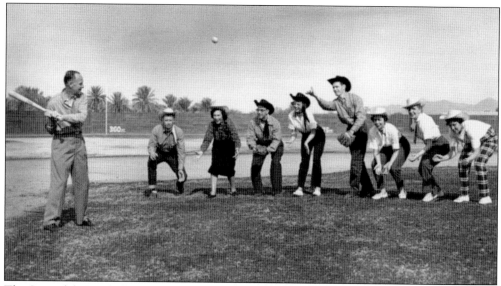
The Scottsdale Baseball Club hit the field at Scottsdale Stadium in this 1950s photograph. The club helped raise money to build the stadium and also hosted spring training games. In 1961, the Scottsdale Chamber of Commerce created the Scottsdale Charros, and the baseball booster group took over spring training duty. (Courtesy of Scottsdale Charros.)

Spring training programs for the Boston Red Sox, Baltimore Orioles, and Seattle Pilots featured the art of nationally syndicated cartoonist Walt Ditzen, who moved to the Phoenix area in the 1950s. The popular "Fan Fare" strip showcased everything from baseball to bowling and appeared in about 200 newspapers. The artist drew on Arizona themes to create the humorous cartoons for spring training programs, like the one at right for the 1964 Boston Red Sox at Scottsdale Stadium. When the Seattle Pilots landed in Tempe, Ditzen poked fun at Seattle's rainy weather, as seen in the program below from 1969. (Right, courtesy of Rodney Johnson, Mesa Historical Museum; below, courtesy of Dave Geary, Mesa Historical Museum.)

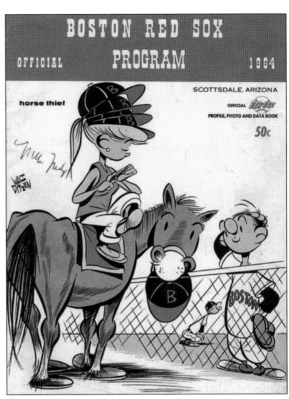

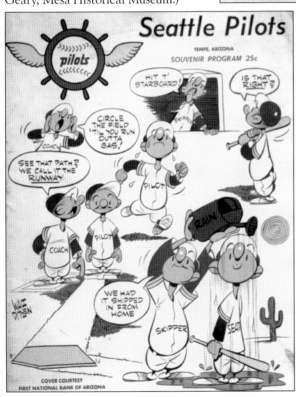

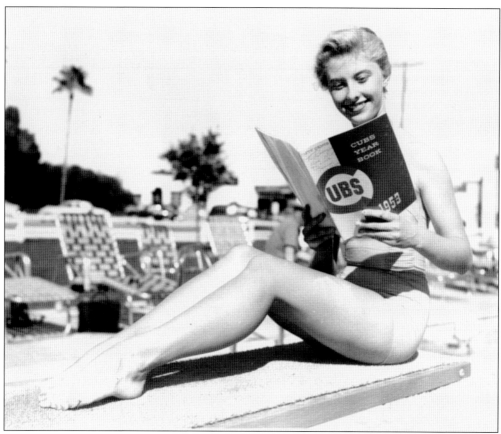

This March 8, 1953, publicity photograph shows a bathing beauty relaxing on a swimming pool diving board with a Cubs yearbook in hand. Boosters pulled out all the stops to promote baseball and Arizona's sun-drenched springs. (Courtesy of Tim Sheridan Collection and boysofspring.com, Mesa Historical Museum.)

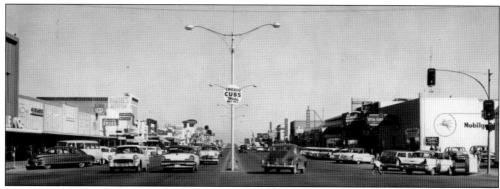

Mesa showed off its spring training pride in the 1950s with a prominent sign alerting motorists to the Chicago Cubs schedule. Mesa boosters capitalized on the Cubs fever that hit the city every spring as fans turned out to see baseball greats like Ernie Banks and Fergie Jenkins. (Courtesy of Robert Brinton, Mesa Historical Museum.)

In this 1952 photograph, Chicago Cubs players (from left to right) Warren Hacker, Johnny Klippstein, Tom Simpson, and Harvey Gentry are shown leaving the Maricopa Inn in Mesa for practice at Rendezvous Park. (Courtesy of Linda Abbott.)

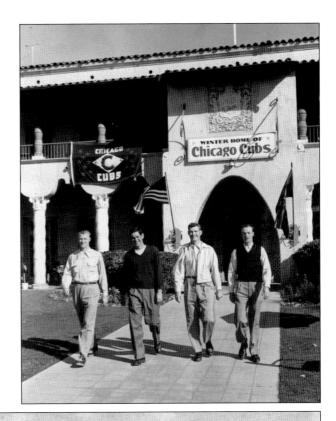

In 1961, the Chicago Cubs hosted a western-style barbecue at the stables of the Arizona Biltmore, one of the Valley's premier resorts. The club invited players, coaches, scouts, baseball writers, and their spouses for steak dinners. (Courtesy of Richard and Sue Burwell.)

**THE MANAGEMENT TEAM
OF THE
CHICAGO NATIONAL LEAGUE BALL CLUB
CORDIALLY INVITES**

🎪 Each of the players at the Chicago Cubs spring training camp-

🎪 The Cubs officers, personnel, scouts and coaching and mangagerial and personnel connected with our associated clubs-

🎪 The baseball writers covering our spring training camp-

to enjoy a Western style outdoor barbecue steak dinner at the Arizona Biltmore Stables

WEDNESDAY EVENING, MARCH 15, 1961
6:30 P. M.

🎪 Your wife is cordially invited to join the party.

If you do not have transportation, check with Don Biebel who will make arrangements for you.

The entrance to the Arizona Biltmore grounds is on 24th Street at Missouri Avenue. (Near Camelback Road) in Phoenix

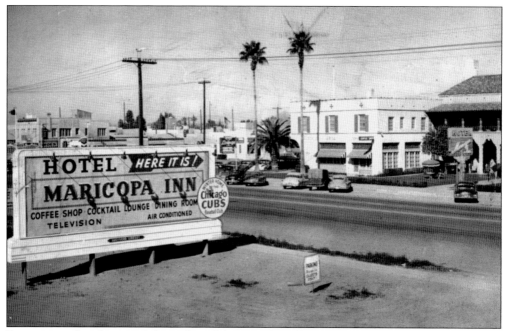

Every spring, hotels around the Valley of the Sun played host to teams and out-of-town baseball fans. They pitched amenities like swimming pools, cocktail lounges, and televisions in hotel rooms as well as the state's sunny skies. The Maricopa Inn in Mesa (above) was the spring training home of the Chicago Cubs and did not miss the opportunity to promote its affiliation with the team on its sign. The contemporary Hotel Valley Ho in Scottsdale (below) opened in 1956, the same year as the new Scottsdale Stadium. The resort drew well-heeled visitors and baseball's elite, including future hall of famers Ted Williams and Bob Feller. (Above, courtesy of Vic Linoff, Mesa Historical Museum; below, courtesy of Scottsdale Historical Museum.)

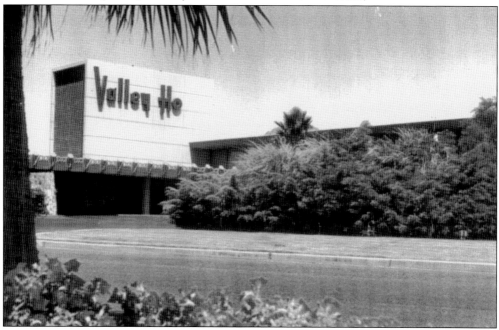

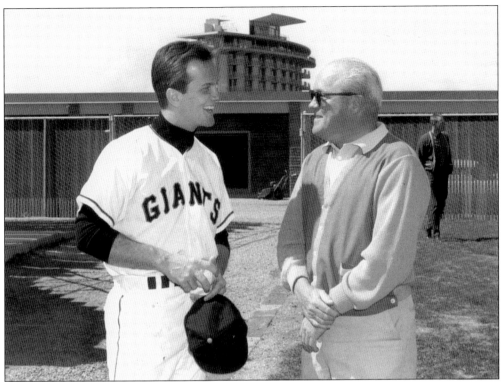

The Francisco Grande resort was a favored desert hideaway for singer Pat Boone (above, left), who dons a San Francisco Giants uniform in this March 3, 1964, photograph with Giants owner Horace Stoneham. Boone took part in opening ceremonies at the resort and was also involved in an adjacent housing development. Stoneham developed the resort with hopes that it would serve as both a spring training camp and year-round luxury resort complete with an 18-hole golf course. The resort boasted unique architectural features (below), such as an overhang on the hotel tower that resembled the brim of a baseball cap and flower beds in the shape of baseball bats and balls. The Francisco Grande drew celebrities like John Wayne, who kept a penthouse suite there, and actors like Dale Robertson and Gale Gordon. (Above, courtesy of Francisco Grande Hotel & Golf Resort; below, courtesy of Richard and Sue Burwell.)

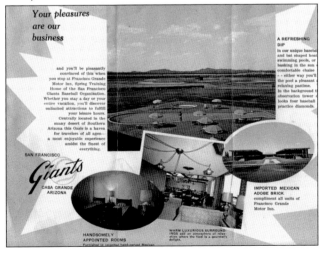

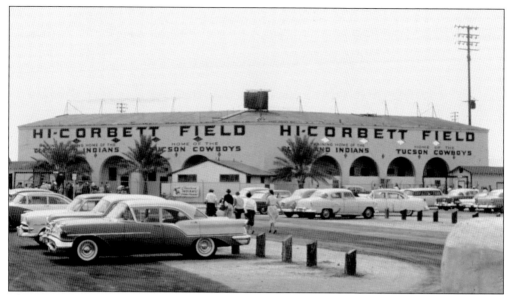

The Cactus League has been a mainstay in the state for nearly 60 years. In its early days, major-league teams played at just a handful of stadiums around the state, making games a popular outing for residents. Stadiums like Hi Corbett Field in Tucson (above) and Rendezvous Park in Mesa (below) drew well-dressed fans, with ladies in dresses and some men in ties. The dress code for spring training games would dramatically loosen over the years with fans donning T-shirts, shorts, and flip-flops. But one thing never changed: big, enthusiastic crowds filling ballparks. (Above, courtesy of Tim Sheridan and boysofspring.com, Mesa Historical Museum; below, courtesy of Mesa Historical Museum.)

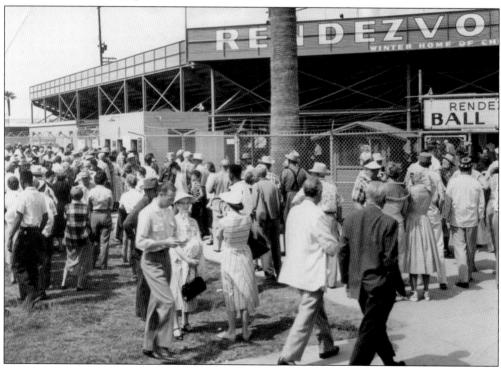

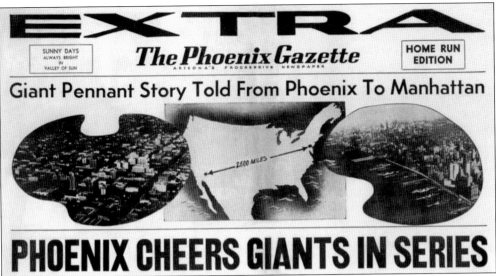

When the New York Giants faced off against the Cleveland Indians in the 1954 World Series, it was the news of the day in Phoenix. *The Phoenix Gazette* published a Home Run Edition trumpeting the city's connection to the Giants. Headlined, "Giant Pennant Story Told From Phoenix To Manhattan," the special extra was flown to New York. (Courtesy of Ted and Alice Sliger, Mesa Historical Museum.)

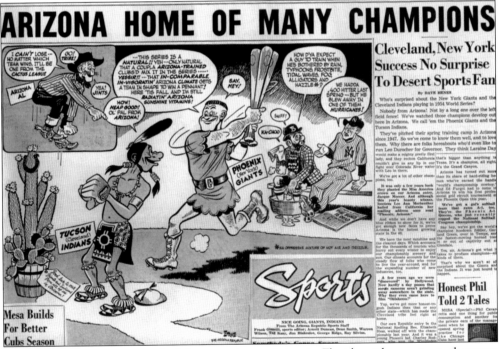

The Phoenix Gazette extra poked fun at spring training in Florida with a cartoon character boasting, "That incomparable, invigoratin' Arizona climate gets a team in shape to win a pennant!" Meanwhile, Brooklyn Dodgers and New York Yankees players bemoan Florida weather, with one saying, "We hadda .400 hitter last spring . . . but he blew away in one of them hurricanes!" (Courtesy of Ted and Alice Sliger, Mesa Historical Museum.)

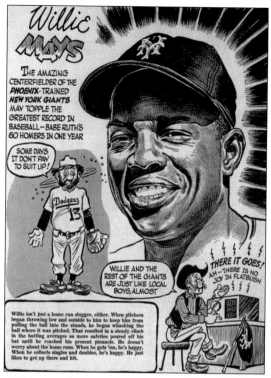

Willie Mays got top billing in *The Phoenix Gazette's* extra (left) after helping get the New York Giants to the World Series. Mays, the paper said, "Doesn't worry about the homeruns. When he gets 'em, he's happy. When he collects singles and doubles, he's happy. He just likes to get up there and hit." A cartoon Brooklyn Dodgers player is clearly dazed by Mays and notes, "Some days it don't pay to suit up." Meanwhile, a cartoon cowboy praises Mays. "Willie and the rest of the Giants are just like local boys, almost." Like a local, Mays visited the restaurant at Mesa's Buckhorn Baths (below) with owner Ted Sliger (center) and an unidentified restaurant employee (right). (Courtesy of Ted and Alice Sliger, Mesa Historical Museum.)

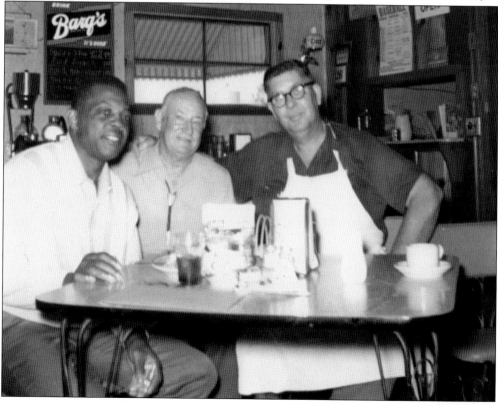

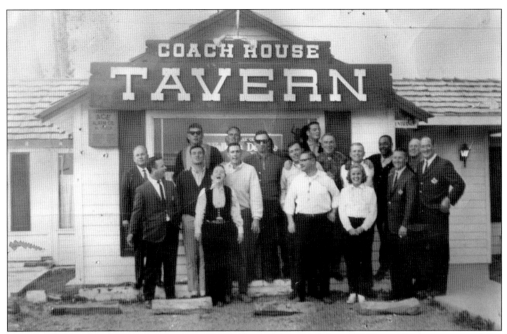

The Boston Red Sox set up spring training camp in Scottsdale in 1959 and became part of the social scene. Players gather outside Scottsdale's Coach House (above) and joke around at the bar (below) in 1965. Bob and Mary Brower opened the tavern in 1959, and it became a popular hangout during spring training. That tradition continues today with the tavern hosting do-not-miss barbecues after games in March. Patrons there still enjoy star-sightings too. During the 2011 season, hall of famers Fergie Jenkins and Gaylord Perry stopped by the tavern after the Chicago Cubs defeated the hometown San Francisco Giants. (Courtesy of Coach House.)

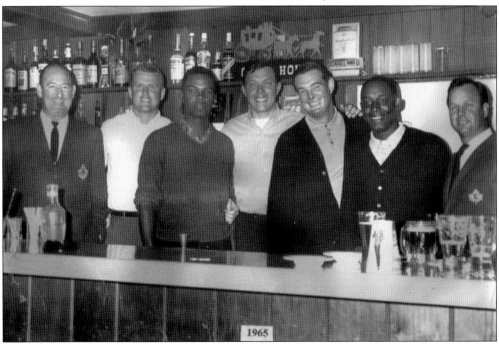

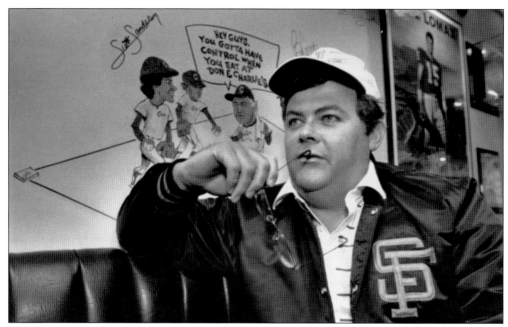

Don & Charlie's opened in Scottsdale in 1981, and owner Don Carson turned the restaurant into a shrine to all things sports over the years. The collection continues to draw baseball fans each spring. Carson poses in 1984 in front of a mural that features, from left to right, Cubs pitcher Scott Sanderson, pitcher Steve Trout, and pitching coach Billy Connors. (Courtesy of *East Valley Tribune*, Mesa Historical Museum.)

Harry & Steve's Chicago Grill in Mesa became a hot spot for Chicagoans when it opened in the 1980s, thanks to Cubs announcer Harry Caray and broadcaster Steve Stone. When the restaurant was sold, it reopened as Sluggo's Sports Grill and later as Diamond's Sports Grille. It remains a popular fan hangout. (Courtesy of *East Valley Tribune*, Mesa Historical Museum.)

Three

BUCKHORN BATHS

Mesa's Buckhorn Baths will forever have a place in spring training history, thanks to the resort's "fountain of youth." In the late 1930s, owners Ted and Alice Sliger were drilling a well and made an amazing discovery. The water was hot and would turn out to be ideal for soothing mineral baths. News of the Sligers' find spread quickly and the Buckhorn soon began drawing scores of guests, including the New York (later San Francisco) Giants. The team would go on to make trips to the Buckhorn for nearly 40 years.

The Sligers' discovery came at a time when Arizona was already well known for its mineral baths and hot springs. Health-seekers came hoping to cure all manner of ailments while tourists made trips for much-needed rest and relaxation. The Buckhorn widely promoted its amenities: one brochure invited guests to visit the modern bathhouse, head to the cooling room, indulge in a Swedish massage, and then "go forth with a glorious sense of rejuvenation."

As the crowds grew at the Buckhorn, so did the resort. The property ultimately featured a restaurant, beauty parlor, golf course, and jaw-dropping taxidermy museum.

In 1946, a twist of fate transformed the Buckhorn. New York Giants owner Horace Stoneham had announced that his team would hold spring training in Arizona and set about finding proper accommodations in Phoenix. According to an *Arizona Republic* news story that year, Stoneham was also hoping to find a suitable hot springs in the area where several members of the team could go to drop excess weight. "We'd much rather have all our players here in Arizona, if we can, than send some of them to Arkansas," he said. The Buckhorn fit the bill for Stoneham and cemented its place in baseball's history books.

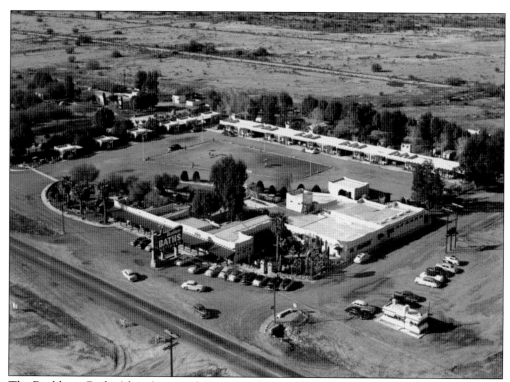

The Buckhorn Baths (above) covered 10 acres in Mesa, offering guests a remote and scenic desert setting just about a 30-minute drive from Phoenix. The resort featured quaint guest cottages, small bathhouses, and a Roman-style bath and cooling room. Over the years, the Buckhorn lured all manner of guests. But it was the resort's famous baseball connection that grabbed the headlines and put owners Ted and Alice Sliger in the spotlight. An undated brochure (below) shows New York Yankee Johnny Mize enjoying a soak. The New York Giants routinely claimed the Buckhorn as its own, but players from other teams, like Mize and Chicago Cub Ernie Banks, did not miss the chance to visit. Retired hall of famer Ty Cobb also was a guest. (Both, courtesy of Ted and Alice Sliger, Mesa Historical Museum.)

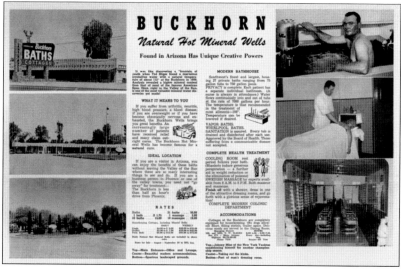

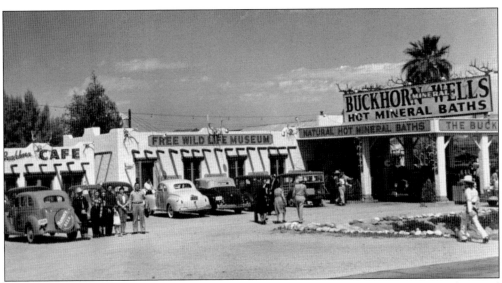

True to its desert setting, the Buckhorn features adobe-style buildings, mature cactus gardens, and cowboy-hat-wearing patrons (above). In the resort's early days, visitors escaped to the outpost for single treatments like a $1.75 bath or a $2 massage, or a weekly cottage stay ($25–$75, depending on the number of guests). One of the Buckhorn's more unique features is the wall surrounding the property (below). It was built with hundreds of old metates, used by Native Americans to grind grains and corn. The metates were found in the vast desert surrounding the property or purchased by the Sligers. The collection wowed out-of-town visitors unfamiliar with Native American practices and tools. (Both, courtesy of Ted and Alice Sliger, Mesa Historical Museum.)

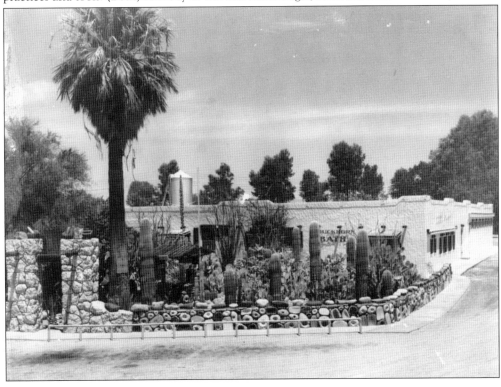

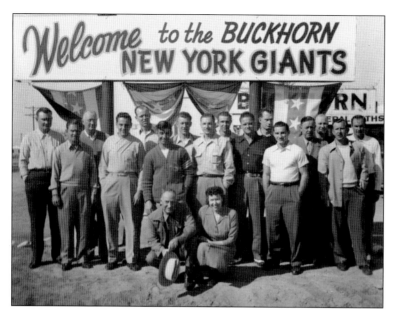

The New York Giants are greeted with large welcome banners hung outside the resort. Players came not only for healing mineral baths and massages, but also for golf, lounging by the pool, and recreational outings. (Courtesy of Ted and Alice Sliger, Mesa Historical Museum.)

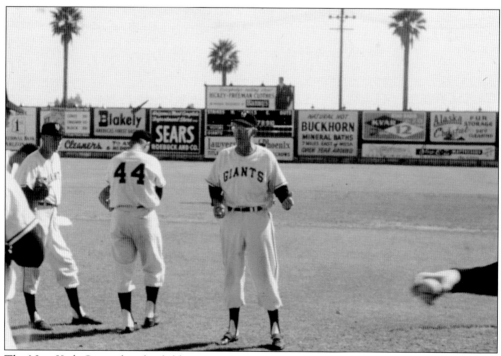

The New York Giants hit the field against the backdrop of an advertisement for the Buckhorn, which promises year-round baths to fans in the stadium. The billboard had prominent placement near the scoreboard, though the resort was well known around the state and did not lack publicity. (Courtesy of Tim Sheridan and boysofspring.com, Mesa Historical Museum.)

San Francisco Giant Willie Mays was a star guest at the Buckhorn and frequently posed for pictures there. In 1965, the "Say Hey Kid" poses with Ted Sliger (left) outside the resort. Mays later inscribed the picture, "To Ted . . . A real good pal." (Courtesy of Ted and Alice Sliger, Mesa Historical Museum.)

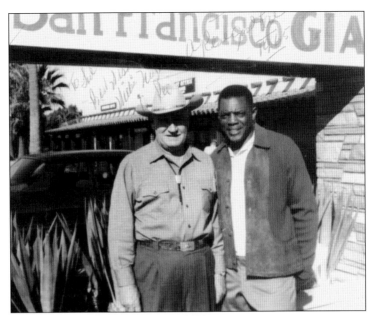

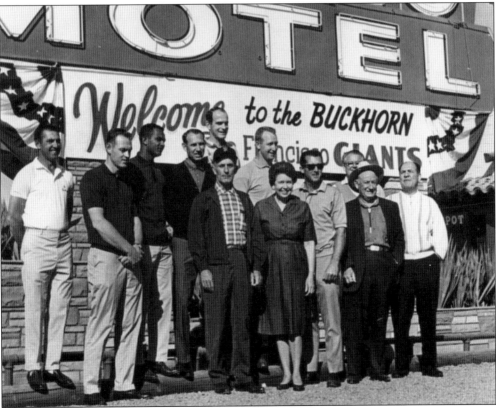

Ted and Alice Sliger made the San Francisco Giants feel at home, welcoming them to Arizona with a banner outside the resort. This team shot includes future hall of famer Gaylord Perry (second row, fourth from left), who enjoyed the resort's amenities and his friendship with the Sligers. (Courtesy of Tim Sheridan and boysofspring.com, Mesa Historical Museum.)

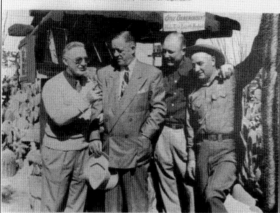

The *New York Daily Mirror* credited the Buckhorn Baths for the New York Giants' so-called sizzle. "Effervescent players bounce around [Phoenix] Municipal Stadium as though they fed on ginger, paprika, horse radish and various other forms of spicy vitamins." From left to right are Giants coach Frankie Frisch, scout Walter Ruether, scout Moose Krause, and Buckhorn owner Ted Sliger. (Courtesy of Ted and Alice Sliger, Mesa Historical Museum.)

A 1951 *New York Daily Mirror* story credited Arizona's sunshine for the New York Giants' success on the field. The photograph captures, from left to right, pitcher Larry Jansen, Buckhorn owner Ted Sliger, outfielder Don Mueller, and masseur Ed Nordquist. The story noted that Nordquist's massages were helping heal Mueller's sprained ankle. (Courtesy of Ted and Alice Sliger, Mesa Historical Museum.)

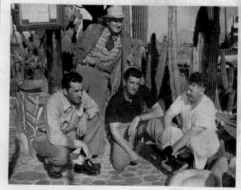

Alice Sliger poses with the New York Giants in 1947, following a meal at the Buckhorn. The Sligers had the photograph framed, and team members signed the back. Manager Mel Ott summed up the team's experience, writing, "They take all the excess off for a week and then add it all back in one evening. We didn't mind a bit." (Courtesy of Ted and Alice Sliger, Mesa Historical Museum.)

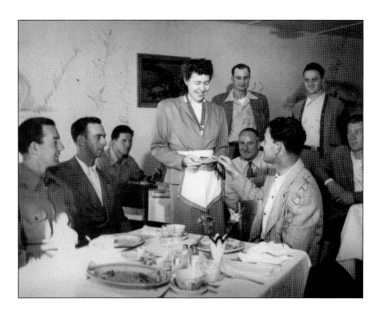

The Sligers (with their backs to the camera) attend an event with catcher Joe Garagiola Sr. (facing camera, in plaid shirt). Garagiola played for two teams that trained in Arizona—the Chicago Cubs and New York Giants—and would go on to broadcasting fame with the Today Show and other television programs. (Courtesy of Ted and Alice Sliger, Mesa Historical Museum.)

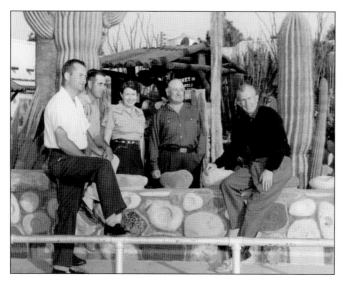

The Phoenix Chamber of Commerce routinely photographed the goings-on at the Buckhorn. This 1957 scene shows, from left to right, former New York Giants second baseman Davey Williams, former Giants pitcher Hoyt Willhelm, Alice and Ted Sliger, and Giants manager Bill Rigney. (Courtesy of Greater Phoenix Chamber of Commerce.)

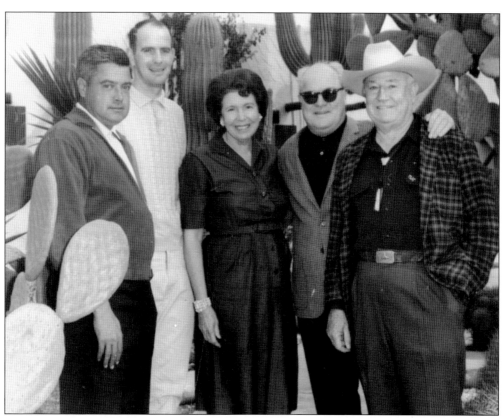

The Buckhorn hosted a who's who of guests for several decades. Pictured in this 1960s photograph are, from left to right, unidentified, San Francisco Giants pitcher and future hall of famer Gaylord Perry, Alice Sliger, longtime Giants owner Horace Stoneham, and Ted Sliger. (Courtesy of Ted and Alice Sliger, Mesa Historical Museum.)

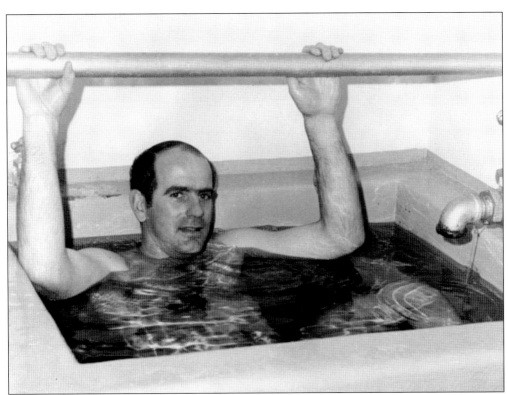

Gaylord Perry is photographed soaking up the "curative" benefits of a mineral bath at the Buckhorn. The resort called its modern bathhouse the "Southwest's finest and largest, housing 27 private baths ranging from 75 gallon tubs to 750 gallon pools." (Courtesy of Ted and Alice Sliger, Mesa Historical Museum.)

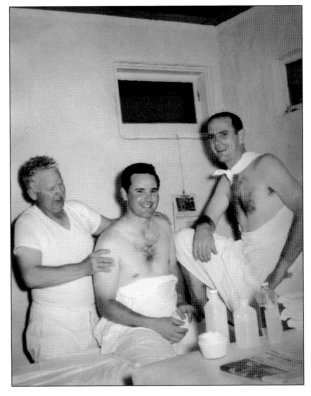

San Francisco Giants catcher Jack Hiatt (center) and Giants pitcher Gaylord Perry (right) pose with Buckhorn head masseur Ed Nordquist in 1966. The resort specialized in Swedish massage and drew players from several teams who needed to work out sore spots during spring training. (Courtesy of Ted and Alice Sliger, Mesa Historical Museum.)

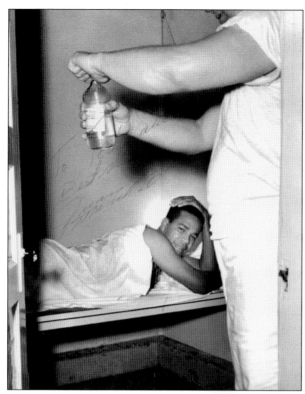

San Francisco Giants pitcher and future hall of famer Juan Marichal was one of the star guests at the Buckhorn. He is shown getting a massage from head masseur Ed Nordquist and later autographed the photographs for Ted and Alice Sliger, writing a simple, "Best Wishes." (Both, courtesy of Ted and Alice Sliger, Mesa Historical Museum.)

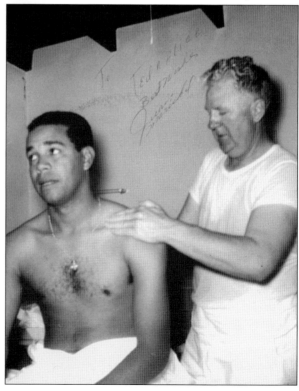

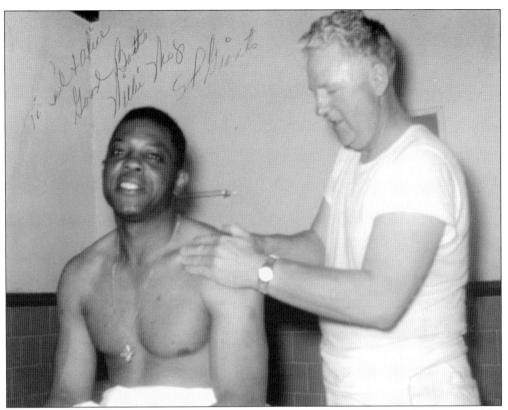

San Francisco Giant Willie Mays, a familiar face at the Buckhorn, is photographed in one of the resort's massage rooms. He autographed one of the photographs with, "To Ted and Alice. Good Baths." (Courtesy of Ted and Alice Sliger, Mesa Historical Museum.)

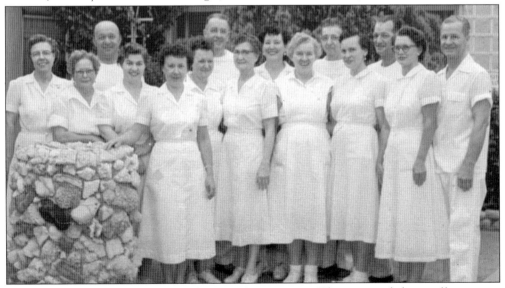

The Buckhorn boasted a large staff to care for its guests. This postcard shows off masseurs, masseuses, nurses, and physiotherapists at the self-described "world famous spa." (Courtesy of Ted and Alice Sliger, Mesa Historical Museum.)

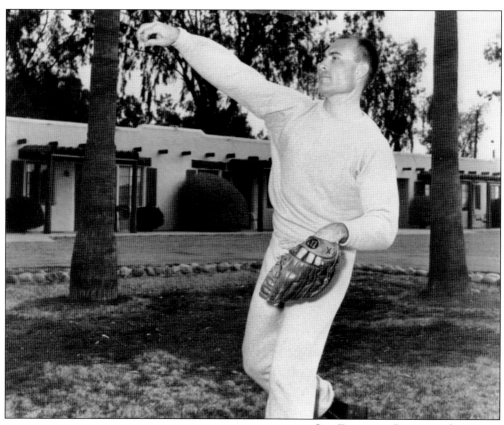

San Francisco Giants pitcher Ron Herbel plays catch at the Buckhorn in 1966. Herbel broke into the big leagues in 1963 with the Giants and played for the team until 1969. (Courtesy of Ted and Alice Sliger, Mesa Historical Museum.)

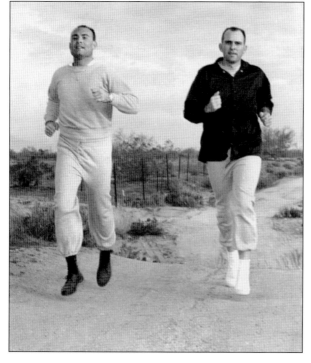

The Buckhorn's remote desert setting made for unusual workout conditions. San Francisco Giants pitchers Ron Herbel (left) and Joe Gibbon get into shape during a run on a dirt trail near the resort. (Courtesy of Ted and Alice Sliger, Mesa Historical Museum.)

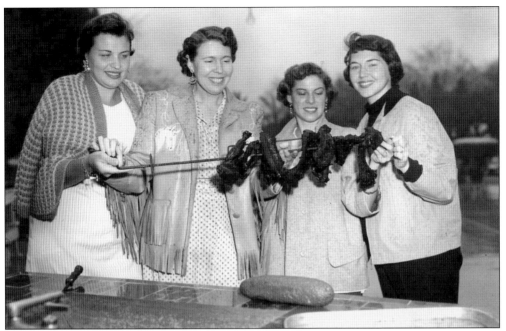

Buckhorn Baths owners Ted and Alice Sliger regularly hosted desert barbecues. Alice Sliger and the wives of several baseball players show off the day's entrée in 1957. From left to right are Mrs. Hoyt Wilhelm, Alice Sliger, Mrs. Al Worthington, and Mrs. Foster Castleman. (Courtesy of Ted and Alice Sliger, Mesa Historical Museum.)

The Buckhorn earned its reputation for rest and relaxation, but guests were also invited to take part in activities like fishing and hunting. New York Giants players pose at the resort in 1957. From left to right are Max Surkont, Don Mueller, Joe Marganeri, and Wes Westrum. (Courtesy of Ted and Alice Sliger, Mesa Historical Museum.)

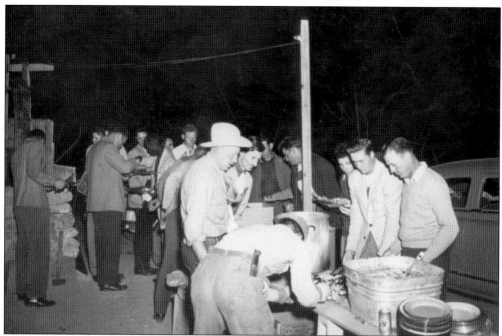

The Sligers' barbecues at the resort were always well attended. Guest Joe DiMaggio, by then retired from playing, enjoyed steak dinners outdoors, according to Alice Sliger. Considered the "Father of the Cactus League," community leader Dwight Patterson (above, in cowboy hat) takes part in a barbecue with members of the Chicago Cubs (below). (Both, courtesy of Tim Sheridan and boysofspring.com, Mesa Historical Museum.)

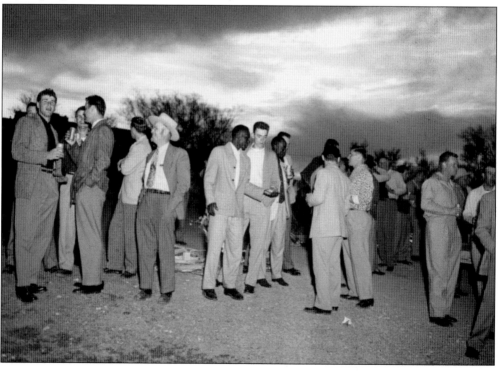

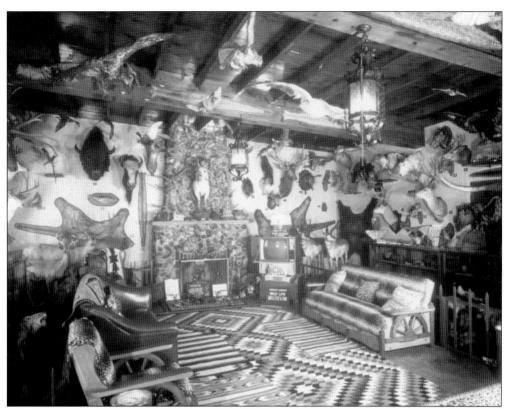

The Sligers operated what they called "Arizona's largest wildlife museum" on their property. The museum featured a unique collection of stuffed animals and boasted more than 400 different specimens. Ted Sliger was a taxidermist and gladly showed off his handiwork for guests. (Courtesy of Ted and Alice Sliger, Mesa Historical Museum.)

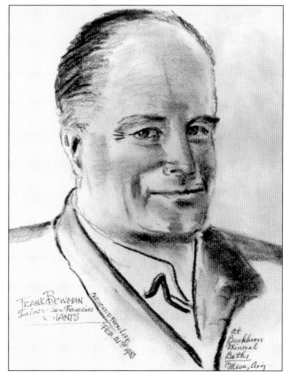

Baseball stars and personalities were captured in unique pencil sketches by George Frederick, a Mesa resident and regular at the Buckhorn. Frederick called the series Sketched from Life. In 1958, he sketched San Francisco Giants trainer Frank Bowman. (Courtesy of Ted and Alice Sliger, Mesa Historical Museum.)

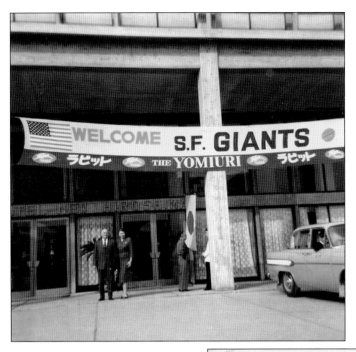

In 1960, Ted and Alice Sliger (left) followed their beloved Giants overseas to see the team's Goodwill Tour of Japan. The couple had an itinerary full of baseball games, sightseeing, and dinners. Among the memorabilia the Sligers brought back home to Mesa was the magazine *Weekly Yomiuri Sports*, dated November 4, 1960 (below). The cover featured Japanese baseball great Shigeo Nagashima (right) and San Francisco Giants great Willie Mays. (Both, courtesy of Ted and Alice Sliger, Mesa Historical Museum.)

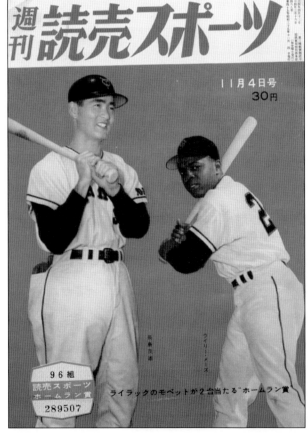

Ted Sliger shot to spring training fame as owner of the Buckhorn and was as much a baseball ambassador as the players themselves. When the New York Giants made it to the World Series in 1954, a local news story credited Sliger's baths with kicking off the Giants' march toward the pennant. According to the story, the Buckhorn "provided hot baths for the sweating off of winter suet and an expert group of masseuses." The resort also "soothed the frayed nerves of the skipper," manager Leo Durocher. Sliger (right) often had his photograph snapped with superstars like San Francisco Giant Willie McCovey. Below, Sliger poses with Chicago Cubs great Ernie Banks (center) and his son Ted Sliger Jr. (right). (Right, courtesy of Ted and Alice Sliger, Mesa Historical Museum; below, courtesy of Tim Sheridan and boysofspring.com, Mesa Historical Museum.)

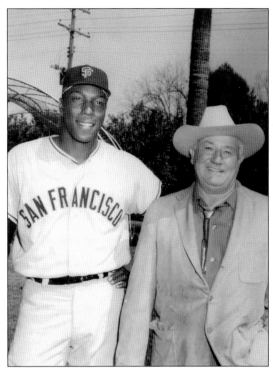

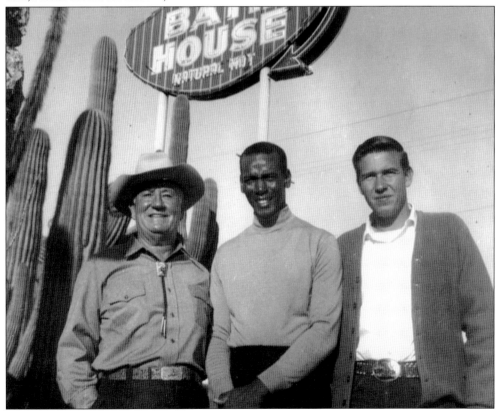

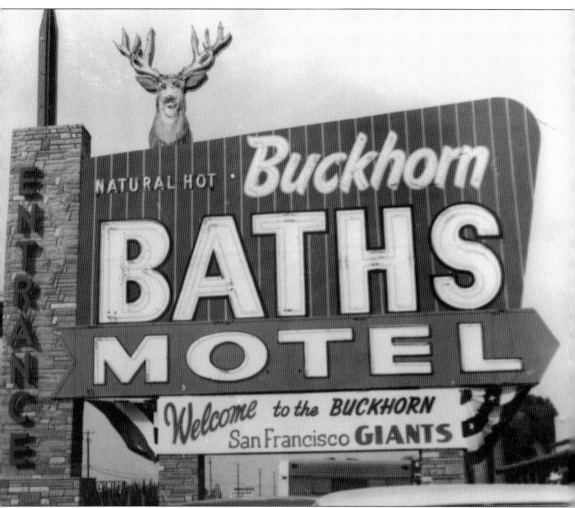

Buckhorn Baths has been referred to as an honorary member of the Cactus League. Today, it is one of the few physical landmarks that remain from the state's early spring training days (Hi Corbett Field in Tucson and the Pink Pony in Scottsdale are two others.) Both Ted and Alice Sliger have passed away, and their resort, though long closed, stands almost frozen in time in Mesa. Preservationists fear that the historic site will fall to development. In 2011, the National Society for Commercial Archeology named the Buckhorn to its "10 Most Endangered Roadside Places" list.

Four

DESERT STAR POWER

Arizona has had no shortage of star power—players, owners, and personalities—since spring training first took hold in 1947. In its early years, fans cheered Joe DiMaggio as he played his last spring training season and Mickey Mantle as he started his first. They eyed legends Ted Williams and Henry Aaron and watched Willie Mays hit a historic spring training home run. And fans became a part of history when they saw Larry Doby, the American League's first black player, take the field with the Cleveland Indians. In more recent years, standouts like Alex Rodriguez, Barry Bonds, and Sammy Sosa drew fans to stadium seats for a glimpse of greatness. After Arizona snagged the Arizona Diamondbacks, its own major-league franchise, in 1995, spring training fever spiked as fans rooted for hometown heroes like pitching ace Randy Johnson.

The Cactus League also saw world champion teams, from the New York Giants and New York Yankees in the 1950s to the San Francisco Giants in 2010. The Arizona Diamondbacks scored their own World Series win in 2001.

Of course, the Cactus League would not have existed without visionaries like Bill Veeck Jr., owner of the Cleveland Indians, and Horace Stoneham, owner of the New York (later San Francisco) Giants. Both men took a chance on Arizona and set up the first official spring training camps in the state. Meanwhile, community leader Dwight Patterson lured the Chicago Cubs here, helping grow spring training at a critical time. Later, in the 1980s, when spring training was in dire straits, then-governor Rose Mofford stepped up to the plate and helped stabilize the Cactus League.

Over the years, the Cactus League spotlight also shined on celebrities, like Hollywood heavyweight Gene Autry, whose California Angels trained part time in Mesa, and legendary Chicago Cubs announcer Harry Caray. That star power helped round out the league's constellation.

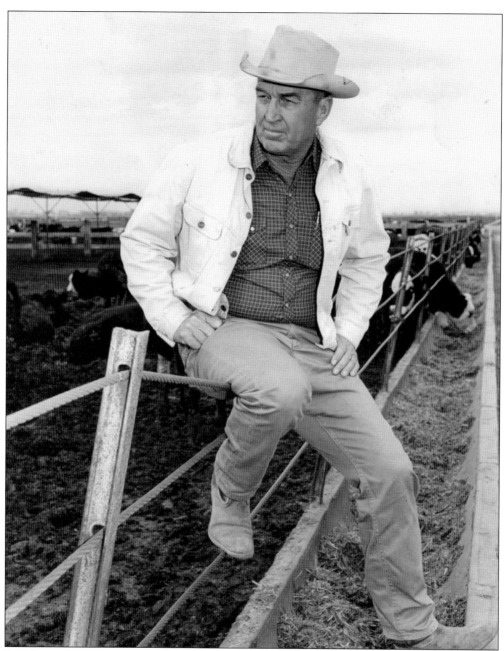

Rancher and community leader Dwight Patterson is often referred to as the "Father of the Cactus League" for luring the Chicago Cubs from the team's longtime home in California to Rendezvous Park in Mesa in 1952. At the time, Florida dominated spring training, followed by California. The Cubs' move gave Arizona three teams with camps here and put the state on the road to the Cactus League. Patterson would go on to serve as Arizona's baseball ambassador, helping promote and expand the league. He also was one of the founders of the Mesa HoHoKams, a baseball booster group, and served as the group's first leader, dubbed "Chief Big Ho." Today, the Cubs play on the aptly named Dwight Patterson Field at Hohokam Stadium in Mesa. (Courtesy of Mesa Historical Museum.)

Bill Veeck Jr. set the Cactus League in motion when he set up spring training camp for his Cleveland Indians in Tucson in 1947. But Veeck made an even greater impact on baseball, enjoying a long career as the always-colorful owner of three major-league teams. Veeck earned a spot in the National Baseball Hall of Fame in 1991. (Courtesy of National Baseball Hall of Fame Library.)

New York Giants owner Horace Stoneham decided to move his team's training site to Arizona for the 1947 season. According to *The Arizona Republic*, Stoneham told Florida officials, "The New York Giants have been offered a substantial cash guarantee by a city in Arizona. In addition, we have an offer to play a series of exhibition games in a city in the Pacific Coast League with assurance of a very satisfactory financial return." According to the newspaper, Phoenix had come up with the cash, a reported $20,000. (Courtesy of National Baseball Hall of Fame Library.)

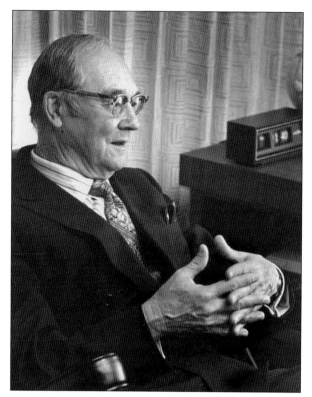

Phoenix developer and New York Yankees owner Del Webb traded spring training sites with the New York Giants and brought his team to Phoenix for one season in 1951. In an *Arizona Highways* magazine story, Giants owner Horace Stoneham was quoted as saying, "It was a pleasure to accede to his request for the transfer. I do want to emphasize, however, that the Giants will be back in Phoenix in 1952." (Photograph by *The Arizona Republic*.)

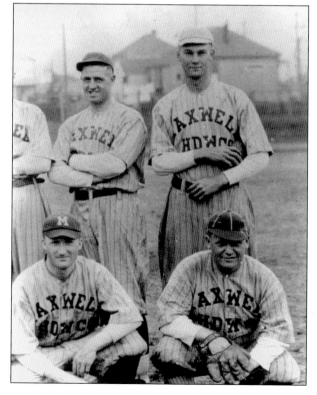

New York Yankees owner Del Webb (second row, far right) was a former player himself as a young man. Webb played for local and company teams. Later in life, the Phoenix developer credited much of his commercial success to his early baseball career and lessons in teamwork, showmanship, and calm in crisis, according to the book *Del Webb: A Man. A Company*. (Courtesy of Del Webb.)

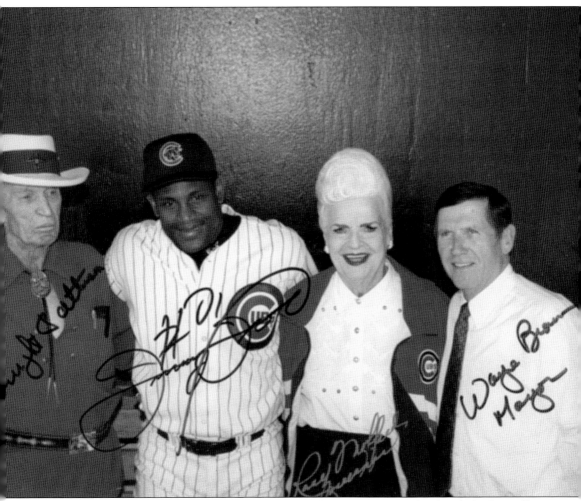

Rose Mofford, Arizona's governor and a former softball champion, is credited with fending off Florida's attempts to lure teams from Arizona and saving the Cactus League in the late 1980s and early 1990s. Mofford was thrust into the job of governor after the impeachment of the state's then governor in 1988. Mofford, already a well-known and likable public servant famous for her beehive hairdo, was immediately charged with stabilizing the government and soothing the state's frayed nerves. It was against that backdrop that Mofford unflinchingly launched an effort to stabilize the Cactus League too. Mofford understood the economic importance of spring training; her commitment and passion helped drive legislation that would keep and attract new teams. Pictured are, from left to right, Dwight Patterson, Sammy Sosa, Mofford, and Mesa mayor Wayne Brown. (Courtesy of Geoffrey Gonsher, Mesa Historical Museum.)

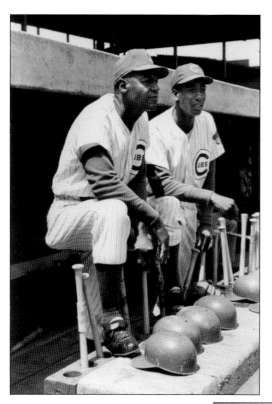

Buck O'Neil (left) and Ernie Banks both broke color barriers in baseball. Banks became the first black player for the Chicago Cubs in 1953, and O'Neil became the first black coach in the major leagues when the Cubs hired him for the job in 1962. The Cubs played at Mesa's Rendezvous Park during those historic times. (Courtesy of National Baseball Hall of Fame Library.)

Cleveland Indians owner Bill Veeck Jr. signed Larry Doby in 1947, making him the American League's first black player. Veeck was dismayed when the team's Tucson hotel denied Doby a room. "It was easy enough for me to tell Larry that these things took time. . . . It was easy enough for me, because it was he who was being told to be patient and to wait," Veeck wrote in his autobiography. (Courtesy of National Baseball Hall of Fame Library.)

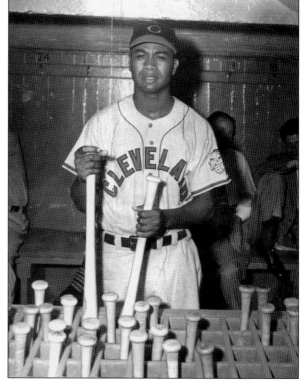

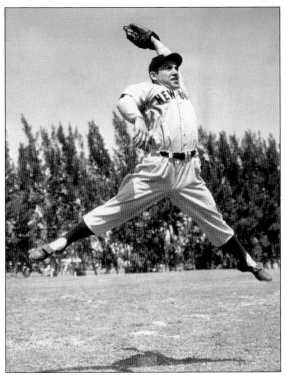

In 1951, hundreds of people mobbed Union Station in Phoenix, hoping to get a glimpse of the New York Yankees arriving for spring training. The team would go on to meet the Giants in the World Series in 1951, and catcher Yogi Berra would be named the American League's Most Valuable Player that year. (Courtesy of National Baseball Hall of Fame Library.)

Mickey Mantle made his first New York Yankees spring training appearance at Phoenix Municipal Stadium in 1951. During training, veteran Joe DiMaggio indicated that 1951 might be his last year in baseball, and speculation abounded that the 19-year-old Mantle would be the legend's successor. (Courtesy of National Baseball Hall of Fame Library.)

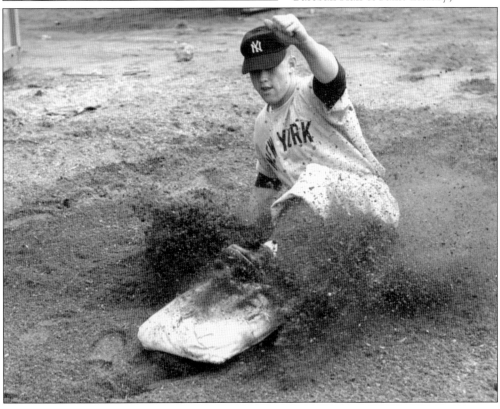

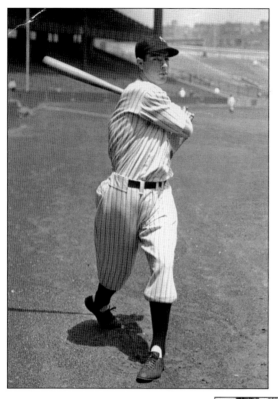

Joe DiMaggio (left) spent the last spring training season of his career at Phoenix Municipal Stadium in 1951. *The Arizona Republic* eagerly announced the arrival of "Joltin' Joe" and reported on his possible retirement. DiMaggio and the Yankees would play exhibition games in both Arizona and California that year, and though DiMaggio was past his prime, he still drew crowds. The *Republic* featured a photograph (below) of a smiling DiMaggio showing an eager three-year-old fan from Los Angeles "how to hold a bat and scare the pitcher." (Left, courtesy of National Baseball Hall of Fame Library; below, courtesy of *The Arizona Republic*.)

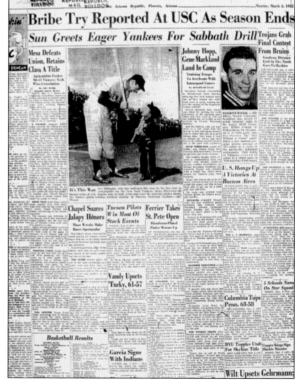

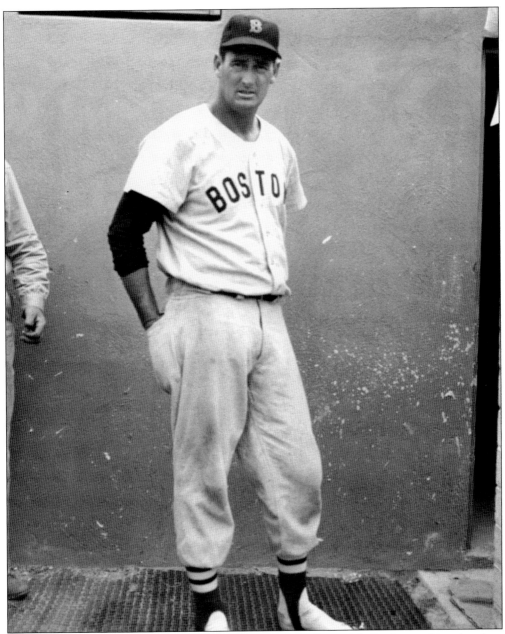

In 1959, the Boston Red Sox set up spring training camp at Scottsdale Stadium, taking the place of the Baltimore Orioles, who had flown to Florida. The move brought legend Ted Williams to Arizona and helped shine a brighter light on the Cactus League. Williams did not stay in the desert Southwest long. He played his last two spring training seasons in Scottsdale and retired after the 1960 season. (Courtesy of Ted and Alice Sliger, Mesa Historical Museum.)

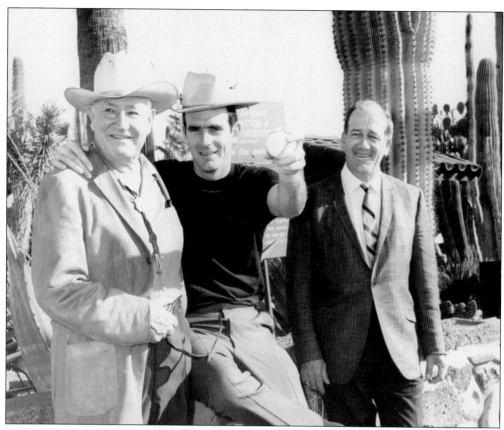

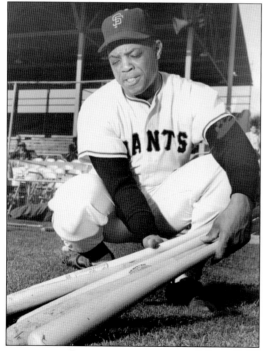

Pitcher and future hall of famer Gaylord Perry played for eight major-league teams, including four that held spring training in Arizona during his career. When Perry was not on the field, he often could be found at Mesa's Buckhorn Baths resort. Pictured at the resort are, from left to right, Buckhorn owner Ted Sliger, Perry, and Murrell Smith, of the Mesa Chamber of Commerce. (Courtesy of Tim Sheridan and boysofspring.com, Mesa Historical Museum.)

Willie Mays, who debuted with the New York Giants in 1951, was forever linked with Phoenix Municipal Stadium when he hit the first spring training home run at the new park in 1964 in a 6-2 win over the Cleveland Indians. The team later moved spring training operations to the Francisco Grande resort in Casa Grande. At the resort's first-ever exhibition game in 1961, Mays wowed fans with a 375-foot home run. (Photograph by *The Phoenix Gazette*.)

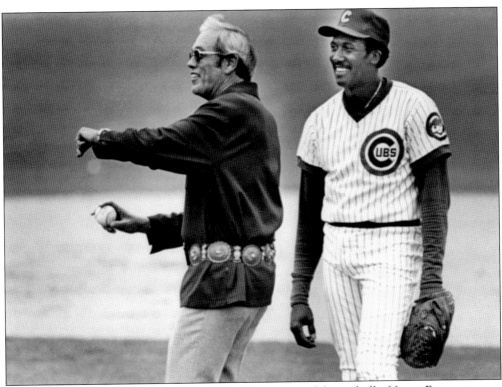

Pitcher and future hall of famer Ferguson "Fergie" Jenkins was signed by the Chicago Cubs in 1966. The Cubs had been training at Mesa's Rendezvous Park but left for California that same year, only to return to Mesa in 1967. Jenkins, a 1971 National League Cy Young Award winner, took the field with Mesa mayor Don Strauch. (Courtesy of Mesa Historical Museum.)

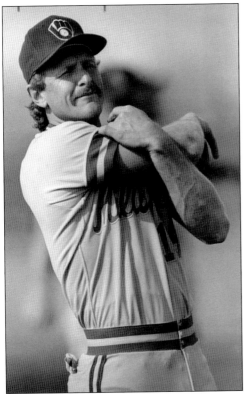

With the Milwaukee Brewers for 20 years, Robin Yount first took the field for spring training in 1974 at Sun City Stadium. In 1978, Yount left spring training there as he contemplated quitting baseball. He returned to the Brewers that May. The team relocated its spring training camp to Chandler's Compadre Stadium in 1986, and the future hall of famer thrilled fans there until his retirement in 1993. (Photograph by *The Arizona Republic*.)

Future hall of famer Ryne Sandberg joined the Chicago Cubs in 1982 and was a longtime fixture at spring training until announcing his retirement in 1994. That retirement was short-lived, and Sandberg was playing again with the club at Mesa's Hohokam Stadium by spring training 1996. (Photograph by *East Valley Tribune*; courtesy of Mesa Historical Museum.)

Cactus League fans turned out in droves to see superstar sluggers Barry Bonds (left) and Ken Griffey Jr., who shared a pregame laugh in 1997 at Scottsdale Stadium. Bonds, an Arizona State University star who played for the San Francisco Giants from 1993 to 2007, was named National League Most Valuable Player seven times during his career. Griffey played two stints with the Seattle Mariners (1989–1999 and 2009–2010) and was a fan favorite during spring training at the Mariners' camp at the Peoria Sports Complex. (Photograph by *East Valley Tribune*; courtesy of Mesa Historical Museum.)

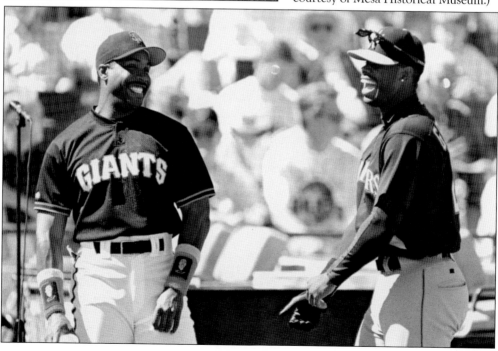

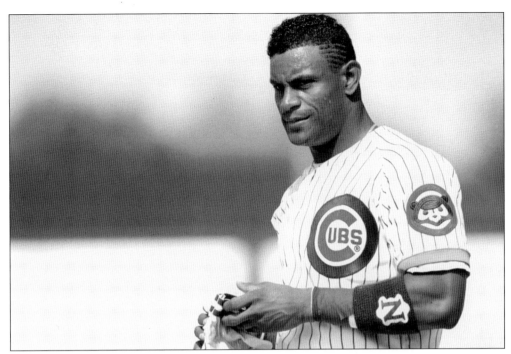

Superstar slugger Sammy Sosa joined the Chicago Cubs for spring training at Mesa's Hohokam Stadium in 1992. The slugger ended his playing career in 2007 with the Texas Rangers, who trained at Surprise Stadium. Sosa is shown at spring training in 1994. (Photograph by *East Valley Tribune*; courtesy of Mesa Historical Museum.)

Alex Rodriquez debuted with the Seattle Mariners in 1994, the year the team set up its spring training camp at the new Peoria Sports Complex. He joined the Texas Rangers in 2001, and the team moved into the new Surprise Stadium for spring training in 2003. (Photograph by *East Valley Tribune*; courtesy of Mesa Historical Museum.)

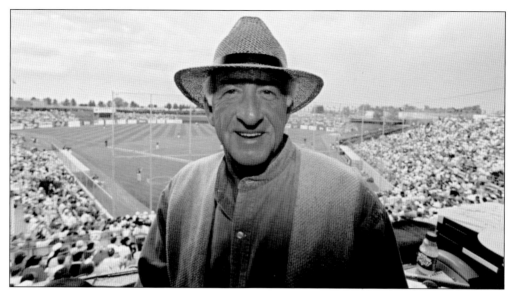

Milwaukee Brewers announcer and former major-league player Bob Uecker has long been a familiar face during spring training in Arizona. Uecker has been the voice of the Brewers for more than 40 years and is pictured at Compadre Stadium in Chandler in 1994. (Photograph by *East Valley Tribune*; courtesy of Mesa Historical Museum.)

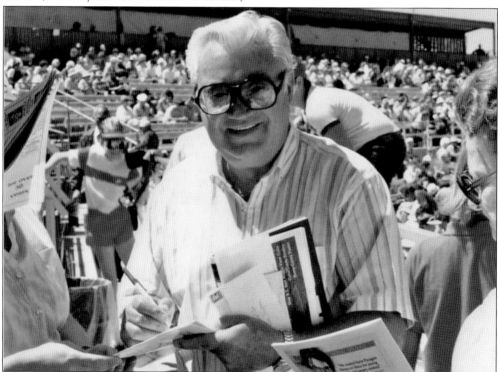

Legendary Chicago Cubs announcer Harry Caray was a favorite of locals and visitors from the Windy City during spring training at Mesa's Hohokam Stadium. Caray could be counted on to sign autographs and belt out his trademark version of "Take Me Out To The Ballgame." (Photograph by *East Valley Tribune*; courtesy of Mesa Historical Museum.)

Five

WHO'S ON FIRST

In the mid-1960s, the Cactus League began what would become a wild roller-coaster ride spanning three decades. First came fears that the league was dying, then the addition of new teams, and finally, the opening of new ballparks. By the late 1980s, the ride hit a low again, as Florida beckoned with the promise of new facilities and Arizona scrambled to save the Cactus League.

What a difference a year makes. After the 1965 spring training season, two teams—the Boston Red Sox and Chicago Cubs—closed up their camps and moved out of state. That left the Cactus League with just four teams in 1966: two training in California (the Cubs and California Angels) and two training in Arizona (the San Francisco Giants and Cleveland Indians). The exodus prompted skeptics to question the viability of the Cactus League.

But by 1967, the Cubs had returned and began training in Scottsdale. Then in 1969, the Oakland Athletics moved spring training operations to Mesa. That same year, two new major-league franchises set up camp in the state with the San Diego Padres going to Yuma and Seattle Pilots to Tempe. (The Seattle Mariners, another new franchise, would arrive on the Cactus League scene about a decade later). From the late 1960s to the mid-1980s, the Cactus League also saw a building boom with the new Tempe Diablo Stadium in Tempe, Sun City Stadium in Sun City, Hohokam Park in Mesa, Compadre Stadium in Chandler, and Desert Sun Stadium in Yuma.

But the momentum changed once again in the late 1980s. The Cleveland Indians were eyeing a move to Florida for the 1993 spring training season. In fact, Florida was in a position to offer attractive deals to other Cactus League teams. Major League Baseball executives warned that Arizona was in danger of losing spring training, prompting then-governor Rose Mofford to create a baseball task force to fight Florida's attempts to monopolize spring training. Ultimately, the state passed several laws that boosted the Cactus League, the most important of which provided critical public financing to upgrade or build facilities so the state could retain teams and attract new ones.

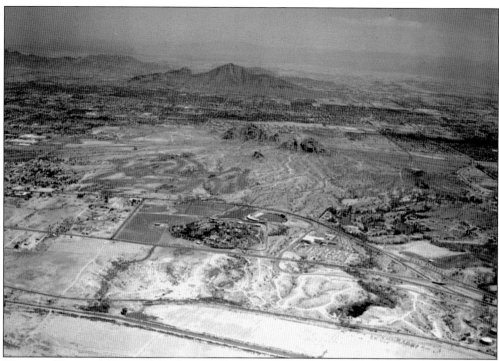

The new Phoenix Municipal Stadium opened in 1964 in Papago Park, which was located in a classically Arizona desert setting. Though relatively remote at this time, the Papago Park area would grow to include many cultural and recreational attractions, and Phoenix Municipal Stadium remained a favorite anchor. In an aerial photograph (above), the stadium is shown behind the popular amusement park Legend City and next to the Phoenix Zoo. The stadium (below) offered fans breath-taking views of surrounding buttes and distant mountains. (Above, photograph by Herb and Dorothy McLaughlin, courtesy of Arizona State University Libraries; below, courtesy of Gary Herron.)

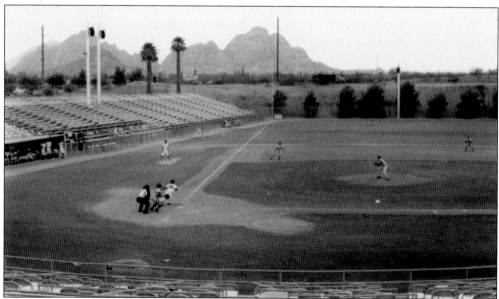

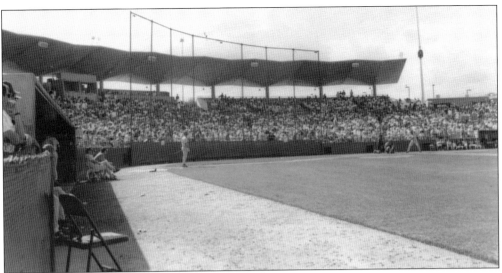

When Phoenix Municipal Stadium opened, it boasted several eye-catching architectural features, including an accordion-shaped concrete roof and unusual stone-faced administration building and ticket booth. The stadium also was the state's first air-conditioned stadium and used evaporative coolers to push cool air through the floor of the inner-bowl seating. (Courtesy of Gary Herron.)

When the New York Giants moved from the Polo Grounds in New York to San Francisco, the team brought light poles across the country and installed them at Phoenix Municipal Stadium. The historic light poles remain at the stadium today. (Courtesy of Phoenix Municipal Stadium.)

Mesa's Rendezvous Park went without a major-league team for three years after the departure of the Chicago Cubs for the 1966 season. But the city got a win in 1969 when it landed the Oakland Athletics. The team would train there for nearly a decade before moving to Scottsdale Stadium and then to Phoenix Municipal Stadium. (Courtesy of Vic Linoff, Mesa Historical Museum.)

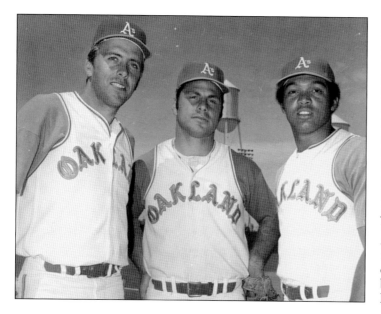

Oakland Athletics players (from left to right) Rick Monday, Sal Bando, and Reggie Jackson pose at Mesa's Rendezvous Park in 1969. Cactus League fans saw the A's go on to win three consecutive World Series in 1972, 1973, and 1974. Coincidentally, Monday, Bando, and Jackson all started their baseball careers at Arizona State University in Tempe. (Courtesy of Tim Sheridan and boysofspring.com, Mesa Historical Museum.)

Oakland Athletics pitcher Rollie Fingers tries to pick off a runner at first base during a Cactus League game at Mesa's Rendezvous Park. The folding metal chairs are placed quite close to the foul line for coaches and players. (Photograph by Larry Ward.)

There were no exploding scoreboards or high tech graphics when the runs were put up by hand from a narrow catwalk in left-center field at Mesa's Rendezvous Park. An awning gave little relief from the sun for members of the Mesa HoHoKams, the city's baseball booster group, which provided the scoreboard crew. (Photograph by Larry Ward.)

The bare-bones announcer's booth at Mesa's Rendezvous Park shows members of the Mesa HoHokams (far right) and Oakland Athletics announcer Monte Moore (center, with hat) at the microphone. (Courtesy of Tim Sheridan and boysofspring.com, Mesa Historical Museum.)

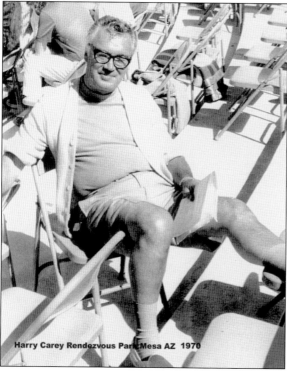

Before he became an icon with the Chicago Cubs, Harry Caray spent a year with Monte Moore announcing Oakland Athletics games. Here, he took the microphone into the stands to get some sun at Mesa's Rendezvous Park. A few years later when the Cubs played at Hohokam Stadium, the popular Caray needed a security escort to get through the crowd from the press box. (Photograph by Larry Ward.)

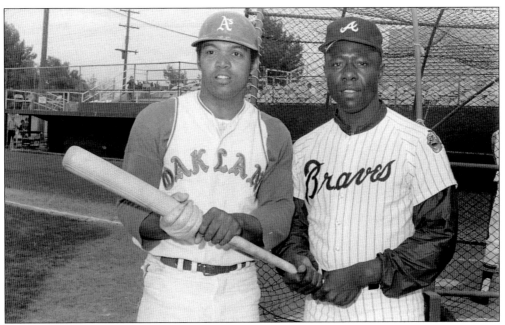

In 1971, fans at Mesa's Rendezvous Park got a look at sluggers and future hall of famers Reggie Jackson, rightfielder for the Oakland Athletics, and Henry Aaron, whose Atlanta Braves made a stop in Arizona during spring training. Arizona fans would see Aaron again when he played for the Milwaukee Brewers, which held spring training at Sun City Stadium. (Photograph by Larry Ward, courtesy of Mesa Historical Museum.)

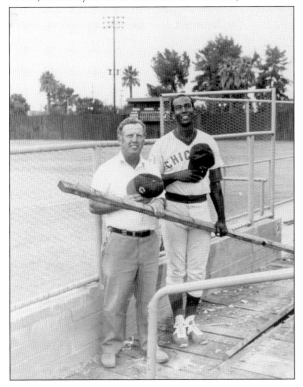

Baseball fan and Rendezvous Park groundskeeper Truck Dayton (left) and Chicago Cub Ernie Banks remove their hats and pay respects to the old stadium in its last year. The trend toward new facilities for spring training forced the demolition of the historic stadium in 1976. (Courtesy of Trina Fitch Kamp, Mesa Historical Museum.)

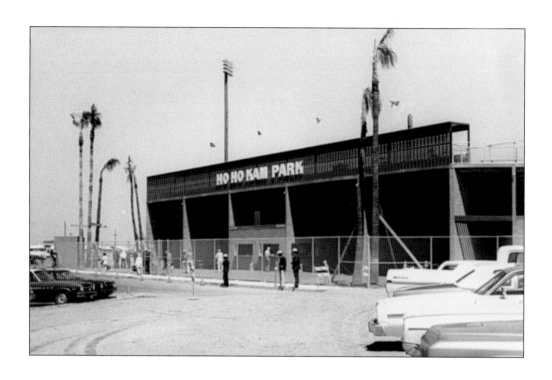

Mesa dedicated Hohokam Stadium in 1977, bringing a larger, state-of-the-art facility to the city. The Oakland Athletics had already been training at the city's former stadium and continued at Hohokam Stadium through 1978 and then departed for Phoenix Municipal Stadium. In 1979, Mesa welcomed the Chicago Cubs back to the city after a long absence and has hosted the team ever since. During the 1980s, the Chicago Cubs would see unprecedented attendance at Hohokam Stadium and rank as the Cactus League's biggest draw. (Above, courtesy of Vic Linoff, Mesa Historical Museum; below, photograph by *East Valley Tribune*, courtesy of Mesa Historical Museum.)

The Chicago Cubs mascot and Cub Rafael Palmeiro welcome faraway fans to sunny Arizona with a sign reading, "Wish You Were Here! At Spring Training in Arizona." (Courtesy of Trina Fitch Kamp, Mesa Historical Museum.)

Hollywood millionaire Gene Autry was awarded the American League–expansion Los Angeles Angels (later Los Angeles Angels of Anaheim), and the club joined the Cactus League in 1961. Autry set up spring training headquarters in Palm Springs, California, but the team had practice facilities in Mesa (pictured here) as well. The location where the team played is now called Gene Autry Park. (Courtesy of Vic Linoff, Mesa Historical Museum.)

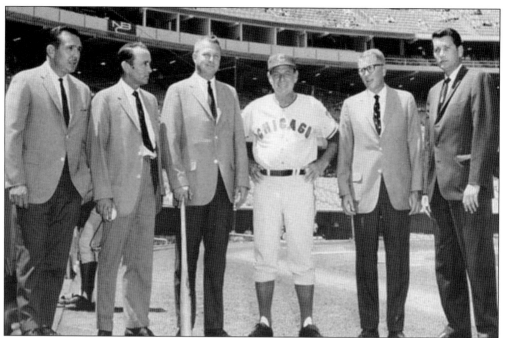

In 1967, Scottsdale sent a delegation to Chicago's famed Wrigley Field to officially welcome the Chicago Cubs as the newest team to hold spring training at Scottsdale Stadium. The group includes members of the Scottsdale Charros booster group and Scottsdale mayor Bud Tims (far right). (Courtesy of Scottsdale Charros.)

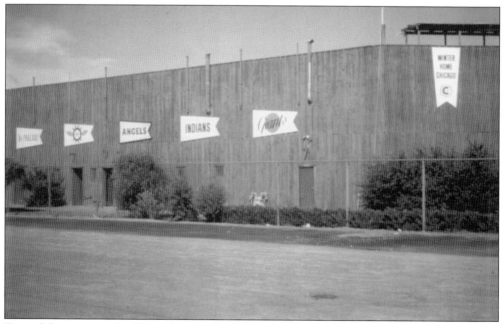

Scottsdale promotes the Cactus League along the west wall of the stadium with white pennants recognizing the Oakland Athletics, Seattle Pilots, California Angels, Cleveland Indians, and San Francisco Giants, along with its own spring training team the Chicago Cubs. In 1982, the stadium would become the Giants longtime host. (Courtesy of Scottsdale Historical Museum.)

"Mr. Cub" and future hall of famer Ernie Banks took the field at Scottsdale Stadium for many spring training seasons until his retirement in 1971. Banks was a fan favorite, seen here at the stadium signing autographs. (Photograph by the *Scottsdale Progress*, courtesy of Charlie Vascellaro.)

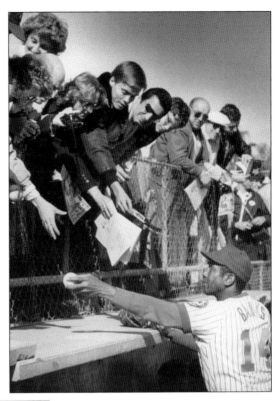

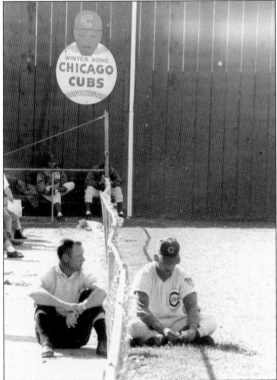

Spring training was much more casual in 1970 when former Arizona State University (ASU) baseball coach Bobby Winkles (left) could have a conversation at Mesa's Rendezvous Park with one of his former ASU players Larry Gura (right) when Gura was playing for the Chicago Cubs. (Photograph by Larry Ward.)

In January 1989, fans line up outside Scottsdale Stadium for San Francisco Giants tickets. A March game between spring training favorites the Giants and Chicago Cubs sold out on the first day of ticket sales. (Photograph by *The Arizona Republic*.)

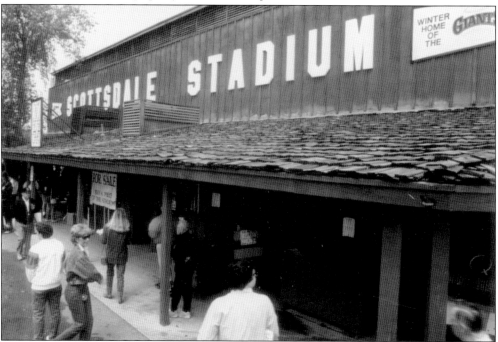

Scottsdale opted to build a new stadium for the 1992 season. Crowds enjoy the final days of the old stadium, which announced a special deal on a large white banner reading, "For Sale Buy A Piece Of The Stadium." Items for sale included original folding chairs and wooden lockers used by greats like Willie Mays. (Courtesy of Scottsdale Historical Museum.)

Tempe got a boost in 1969 when an expansion brought the American League Seattle Pilots to the city's new Tempe Diablo Stadium. The addition of the Pilots brought the number of teams in the Cactus League to seven and put a new city in the rotation for fans. (Courtesy of Tempe Historic Preservation Office.)

This 1970 program shows the matchup between the Cactus League–veteran Cleveland Indians and the rookie Pilots. Tempe Diablo Stadium, the Pilots' spring training home, would go on to host three other major-league teams over the next 40-plus years. (Courtesy of Charles Kapner.)

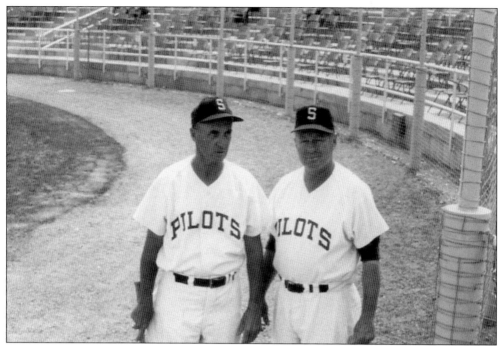

The Seattle Pilots were lead by coach Frank Crosetti (left), a longtime New York Yankee infielder and coach, and manager Joe Schultz (right), a former major-league catcher, shown above at Tempe Diablo Stadium in 1969. Don Mincher (below), also shown at the stadium in 1969, was a first baseman for the Pilots. Despite the team's sunny start in Arizona, it had a gloomy regular season back home with low attendance, poor stadium conditions, and other problems. The Pilots trained in Tempe through 1970, and then the club was sold to a group of Milwaukee investors, becoming the Milwaukee Brewers. (Both, courtesy of Charles Kapner.)

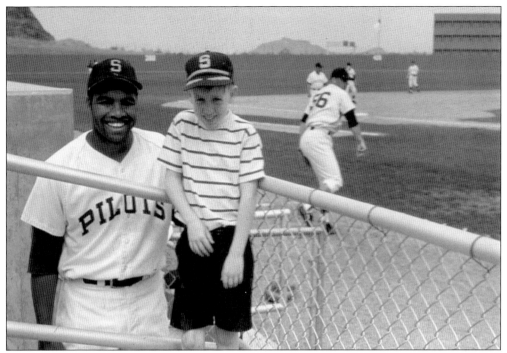

Outfielder Tommy Davis poses in 1969 with young Pilots fan Chris Nelson at Tempe Diablo Stadium. Nelson's father won a contest, and first prize was a trip for two to spring training in Tempe, according to Seattle Pilots baseball historian Charles Kapner. (Courtesy of Charles Kapner.)

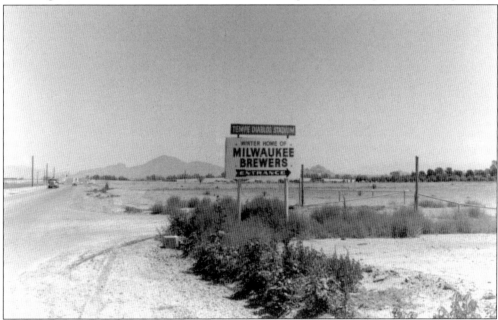

After the Pilots became the Milwaukee Brewers, the new team agreed to continue training at Tempe Diablo Stadium. The club opened camp in 1971 but only remained through the 1972 season, before heading to a new stadium in Sun City. The move would leave Tempe Diablo without a major-league tenant for four years. (Courtesy of Tempe History Museum.)

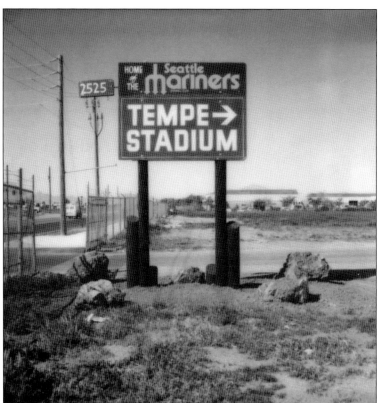

Thanks to another expansion, the American League Seattle Mariners decided to set up spring training camp at Tempe Diablo Stadium in 1977. The team brought several stars to the Cactus League, including first baseman Alvin Davis (named 1984 Rookie of the Year), All Star and Gold Glove winner Ken Griffey Jr., and the "Big Unit," pitcher Randy Johnson. (Courtesy of Tempe History Museum.)

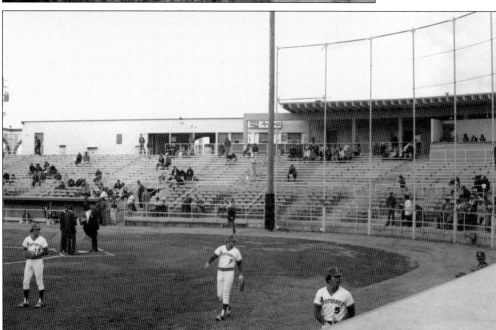

The Seattle Mariners made Tempe their longtime home but opted to move operations to the new Peoria Sports Complex in 1994. The complex hosts both the Mariners and the San Diego Padres. (Courtesy of Tempe Historic Preservation Office.)

Tempe ushered in a new era when a fourth major-league team, the California Angels (later The Los Angeles Angels of Anaheim), set up spring training camp at Tempe Diablo Stadium (above) in 1993. The Angels would go on to become one of the Cactus League's marquee teams. In 2002, the team thrilled fans with a World Series win over another Cactus League–trained team, the San Francisco Giants. The ever-popular Angels (below) remain at Diablo Stadium today. (Above, courtesy of Tempe History Museum; below, courtesy city of Tempe.)

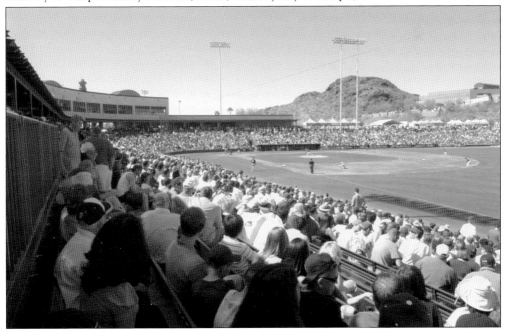

Yuma saw its first major-league team, the Baltimore Orioles, set up spring training camp in 1954, but the deal lasted just one year. The city landed its second team, the San Diego Padres, in 1969 at the new Desert Sun Stadium. Among the selling points was Yuma's relatively close proximity to San Diego, which helped draw fans to Arizona for spring training. (Photograph by Kendall Kards, courtesy of Charlie Vascellaro.)

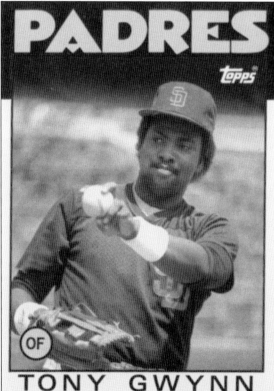

The San Diego Padres' move to Yuma brought plenty of stars and a few future hall of famers to Arizona. Right fielder Tony Gwynn, called "Mr. Padre," joined the Padres in 1982 and would spend his entire career with the club, retiring in 2001. He was named to the National Baseball Hall of Fame in 2007. (Courtesy Rodney Johnson, Mesa Historical Museum.)

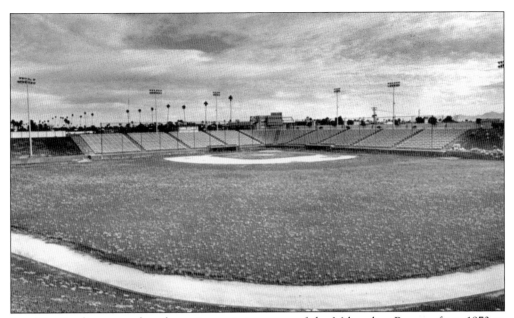

Sun City Stadium served as the spring training camp of the Milwaukee Brewers from 1973 to 1985. Fans there got the chance to see the great Henry Aaron start his first spring training season with the Brewers in 1975, the year after he broke Babe Ruth's home run record. The sale of Sun City Stadium forced the club to move to Chandler; the Sun City Stadium was later demolished. (Photograph by *The Arizona Republic*.)

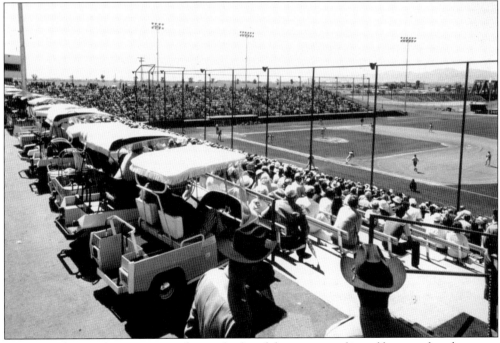

Sun City is known for its retirees, who can be found driving around in golf carts rather than cars. When the Sun City Stadium opened, planners set aside special "golf cart" parking to appeal to baseball fans there. (Courtesy Charlie Vascellaro, Mesa Historical Museum.)

The Milwaukee Brewers hit the field at Sun City Stadium for practice in 1982. Here, second baseman Jim Gantner takes a series of swings in the netted batting cage. (Photograph by Jim Painter.)

Milwaukee Brewers pitcher Pete Vuckovich (center) swings into action during the 1982 spring training season at Sun City Stadium. Vuckovich joined the club in 1981 and stayed through 1986 when he retired. He was the 1982 American League Cy Young Award winner. (Photograph by Jim Painter.)

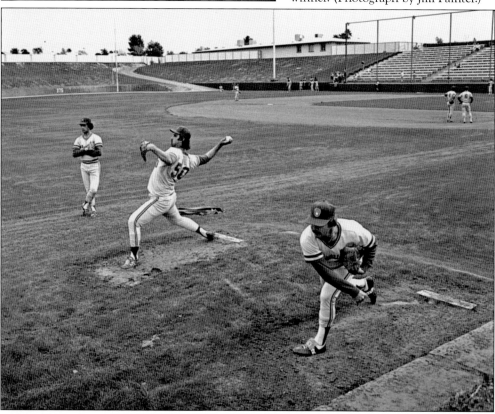

Fans at Sun City Stadium cheered on superstar pitcher and future hall of famer Rollie Fingers (right) for several spring training seasons. Fingers was a fan favorite for his dark handlebar mustache as well as his pitching. (Photograph by Jim Painter.)

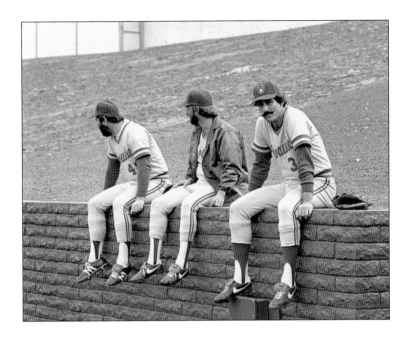

Pete Vuckovich and Rollie Fingers take some downtime inside the Milwaukee Brewers locker room during the 1982 spring training season. (Photograph by Jim Painter.)

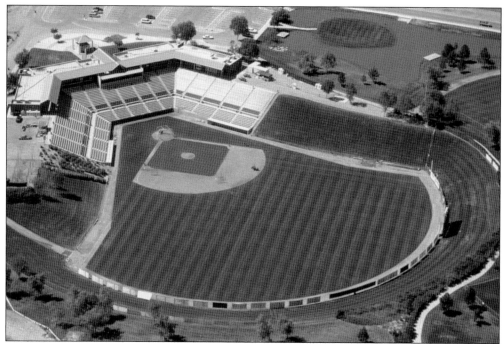

Compadre Stadium in Chandler (above) opened for the 1986 spring training season, luring the Milwaukee Brewers from their spring training base in Sun City. The Brewers enjoyed a long run at Compadre, but when the city scrapped plans to upgrade the stadium, the team decided to leave after the 1997 season. The club moved to the new Maryvale Baseball Park in Phoenix. Compadre still stands today, though it has long been vacant. In the undated photograph below, Brewers players (from left to right) Robin Yount, Ben Oglivie, and Paul Molitor look over Compadre as it is being built. (Both photographs by *East Valley Tribune*, Mesa Historical Museum.)

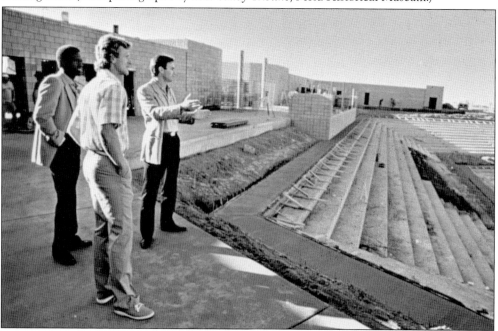

In 1997, Brewers general manager Sal Bando offered his thanks to the fans and Compadres, a booster group, for their support during the team's 11-year run at Compadre Stadium. The Brewers' move out of Chandler that year would be the end of spring training in the city. (Photograph by *East Valley Tribune*, Mesa Historical Museum.)

Milwaukee Brewers pitcher Ron Villone, shown in this 1997 photograph at Compadre Stadium, sits in the right field bullpen and watches his team take on the Oakland Athletics. The white banner in the background welcomes baseball fans, though this would be the last year the team played at the stadium. (Photograph by *East Valley Tribune*, Mesa Historical Museum.)

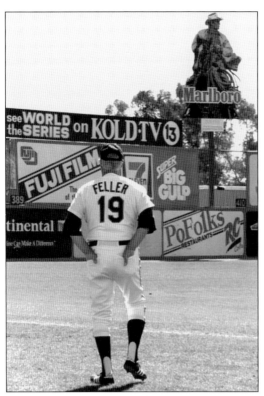

In 1992, the Cleveland Indians, one of the four original Cactus League teams, played their last spring training season at Tucson's Hi Corbett Field. Former Indians pitcher and hall of famer Bob Feller attended the club's matchup with the Chicago Cubs. (Courtesy Tim Sheridan and boysofspring.com, Mesa Historical Museum.)

Tucson was once home to two spring training stadiums—Hi Corbett Field and Tucson Electric Park. Tucson Electric, shown here, hosted the Arizona Diamondbacks and the Chicago White Sox. Both teams departed Tucson for new stadiums in the Phoenix area, leaving Tucson out of the Cactus League rotation. (Courtesy of Pima County Stadium District.)

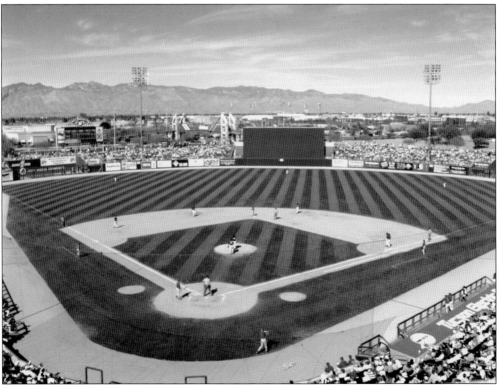

Six

Fan Club

Spring training is about baseball, from the players to the stadiums to the hope that every team reports in the spring with a spotless record and a chance to win it all. Spring training is also about warm sun on the skin of people from cold-weather states who have dreamed for months about an end to dreary winters. But as much as anything, spring training is about the fans.

Some decide on a whim to drive over from California for the weekend. Others plan a year ahead to make the pilgrimage across the country. They come for a single game or for the whole month. Fan Premo Mladenoff had a unique but not entirely unusual ritual. For decades, the utility worker took the overtime money from all those extra hours spent in bone-chilling Chicago winters and came west for the month of March to see his beloved Chicago Cubs. A local sports bar owner always knew when spring training was approaching because the bar started getting phone calls from patrons asking if Mladenoff was in town yet.

Fans have turned out for the big names like Williams, Aaron, Sosa, and Bonds. But they have also showed up for less-than-ideal seasons, like 1990 when a players' strike brought minor-league teams to play in Arizona.

Fans buy box suites, and they buy cheap seats. They ride the bleachers in left field or stretch out in the grass beyond center. They are very young, they are very old, or somewhere in the middle. And since 1947, they have turned out by the millions to watch America's pastime up close in the intimate stadiums found only in the spring.

As legendary Chicago Cubs announcer Harry Caray once said, "It's the fans that need spring training. You gotta get 'em interested. Wake 'em up and let 'em know their season is coming, the good times are gonna roll."

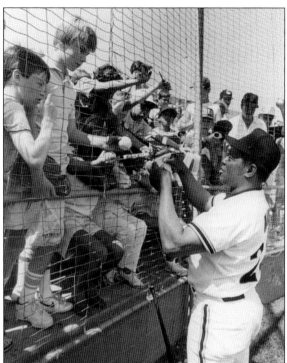

Though Willie Mays spent his playing days at Phoenix Municipal Stadium, he also thrilled fans as a coach for the San Francisco Giants at Scottsdale Stadium. In 1986, the year he returned to the Giants organization, he eagerly signs autographs for fans. (Photograph by *The Arizona Republic*.)

Milwaukee Brewers pitcher Rollie Fingers signs autographs for young boys at Sun City Stadium in 1982. Fans have the chance to see players up close during spring training thanks to the relaxed atmosphere and accessible training fields and stadiums. (Photograph by Jim Painter.)

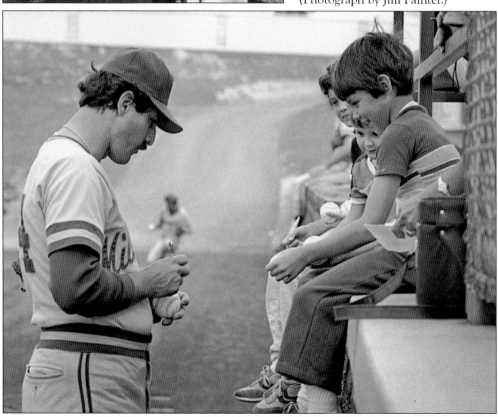

In 1992, eager fans at Scottsdale Stadium crowd around the foul line in left field and use hats as makeshift gloves, hoping to get a ball. It is hard to know who the lucky fan will be in this photograph. (Photograph by *The Arizona Republic*.)

In 1991, a college student from the Bay Area in California could not get a ticket to the sold-out San Francisco Giants game at Scottsdale Stadium. But he found a spot to watch the game between wooden boards in the outfield. (Photograph by *The Arizona Republic*.)

These two quick-thinking fans at a 1982 Cubs game try to shade themselves with programs. If fans have a complaint about spring training, it is that there is little shade over stadium seats. But the sun does not keep fans away, as Cubs games have drawn record crowds. (Photograph by *East Valley Tribune*, courtesy of Mesa Historical Museum.)

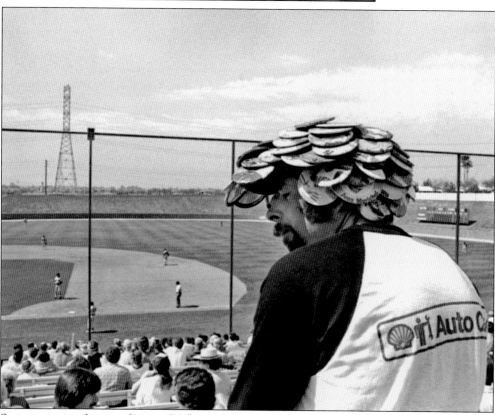

Spring training fans are famous for flaunting their devotion to certain teams. But a fan at Sun City Stadium in 1982 shows off his wide-ranging support with a "button hat" that pays tribute to teams like the Pittsburgh Pirates, New York Yankees, Seattle Mariners, and San Francisco Giants. (Photograph by Jim Painter.)

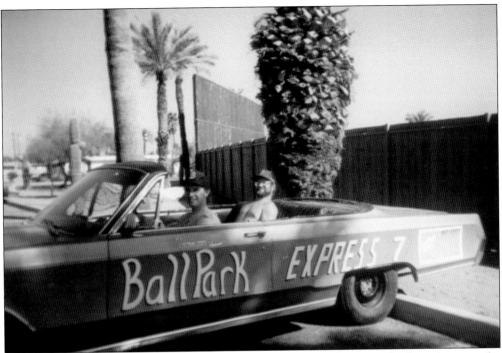

Die-hard spring training fans Carl Dominick (front seat) and Bill Werner (back seat) pose in the Ball Park Express 7, a green convertible parked outside Scottsdale Stadium in 1991. In typical spring training fashion, the stealth fans hopped in and out, as the car did not belong to them. (Photograph by Charlie Vascellaro.)

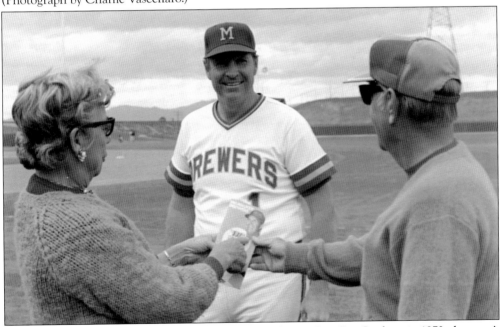

Milwaukee Brewers manager Del Crandall chats with fans at Sun City Stadium in 1973, the team's first year at the new stadium. Crandall's picture was on the cover of an informational pamphlet distributed by the team that year. (Photograph by *Daily News-Sun*.)

Phoenix Municipal Stadium, which has hosted the Oakland Athletics since 1982, still has an old-time ballpark feel. "Muni," as fans call it, draws plenty of spectators who do not need all the frills of newer stadiums. A time line etched in concrete around the concourse tells the story of the stadium's long, rich history. (Photograph by *The Arizona Republic*.)

A players' strike in 1990 brought minor-league teams like the Iowa Cubs and Charlotte Knights to Arizona. The stadiums suffered that year, but some fans still turned out to enjoy the sunny weather and the nation's favorite pastime. (Photograph by *The Arizona Republic*.)

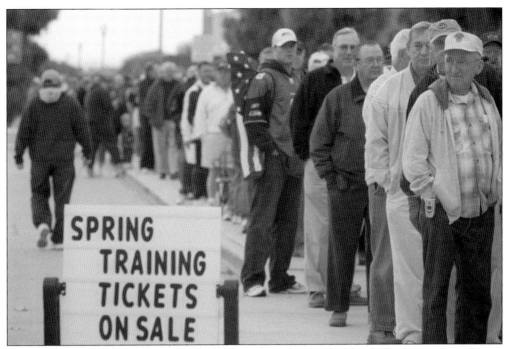

It is a common scene every spring: fans line up outside stadiums to buy baseball tickets well in advance of spring training. Fans shown here wait patiently at Surprise Stadium, which opened in 2002 and hosts the Kansas City Royals and Texas Rangers. (Photograph by *The Arizona Republic*.)

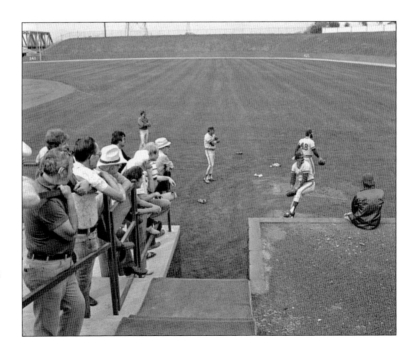

In 1982, a group of fans jockey for a place along a railing at Sun City Stadium to watch Milwaukee Brewers pitcher Rollie Fingers and others practice. Fans love the chance to get close to players during spring training. (Photograph by Jim Painter.)

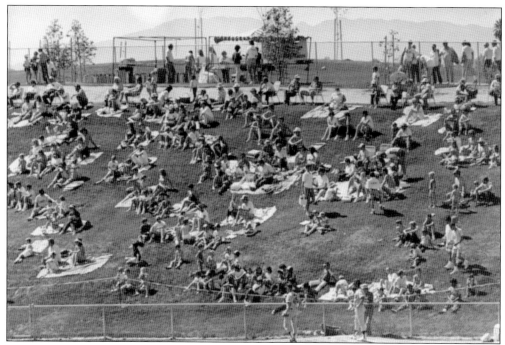

When Chandler's Compadre Stadium opened for its first spring training season in 1986, baseball fans got a boost with inexpensive lawn seating. The grassy area became a favorite place to roll out a blanket and kick back. In 1987, these fans dotting the lawn paid just $2 for a "seat." (Photograph by *The Arizona Republic*.)

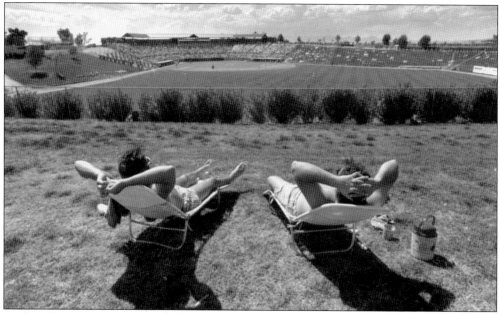

Looking for the cheapest option, these two baseball fans found it at Compadre Stadium in 1990. They actually found it outside the stadium grounds. The men set up lounge chairs and cold drinks, getting a distant look at the matchup between the Milwaukee Brewers and Chicago Cubs. The grassy spot and suntan were free. (Photograph by *The Arizona Republic*.)

Seven

The Lineup

What began as a fledgling four-team league has turned into a 15-team powerhouse and one of the top cultural attractions in Arizona. The Cactus League spans nine communities and draws more than one million locals and tourists to stadium seats each year. Nothing dominates an entire month in the state like spring training.

Modern-day fans may know nothing of the long road baseball took to get to today's Cactus League. The evolution is a story best told through the stadiums themselves. In Arizona's early spring training days, stadiums were just that—stadiums. The vision for a "complex" or two-team training site would come many decades later.

The conditions of some early ballparks are almost unimaginable. Mesa's Rendezvous Park, which first hosted the Chicago Cubs in 1952, offers the perfect snapshot of those simple times: rented bleachers for a too-small stadium, hand-me-down "box seats," a cramped clubhouse. But even Rendezvous Park had something on Municipal Park in Yuma, which hosted the Baltimore Orioles in 1954. That park was initially built as a horse track, so the grandstand did not curve around home plate, creating less-than-ideal seating for fans.

Innovations big and small came over the decades. Some concepts worked, others did not. The new Phoenix Municipal Stadium tried out air conditioning, though the evaporative coolers leaked. Chandler's Compadre Stadium developed lawn seating, which would become a fan favorite at future stadiums. Sun City Stadium added "golf cart" parking for nearby retirees.

In 1994, the Peoria Sports Complex hit the mark when it opened the first-ever spring training site for two teams. Other cities in Arizona and Florida followed suit. Cities also set their sights on building enormous baseball complexes that stretched over 100 or more acres. Almost a city within a city, these sites would include stadiums with 10,000-plus seats, multiple training fields, and myriad fan amenities.

The league's newest stadium, Salt River Fields at Talking Stick near Scottsdale, opened for spring training in 2011. The Chicago Cubs, meanwhile, are expected to move into a new stadium in Mesa in 2013.

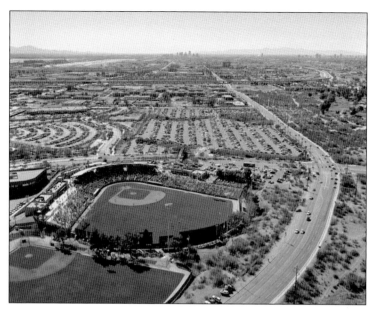

Phoenix replaced its original stadium when it built Phoenix Municipal Stadium in 1964. After the 2003 spring training season, the stadium got a $6.4 million facelift that included a new press box, new dugouts, and improved concourse areas. "Muni" seats roughly 9,500 and hosts the Oakland Athletics. (Courtesy of Todd Photographic Services.)

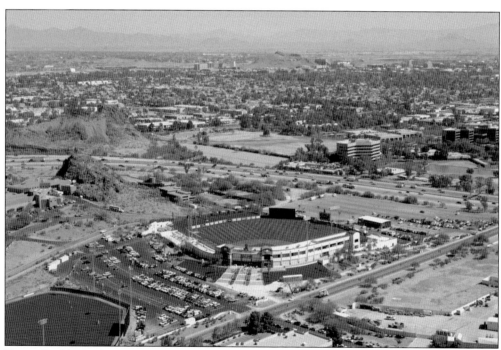

Tempe Diablo Stadium opened for spring training in 1969 and currently hosts the Los Angeles Angels of Anaheim. In 2005, the Tempe Diablo complex underwent a $20 million renovation. The main stadium is dedicated as Gene Autry Field in honor of the former Angels' owner. The stadium seats roughly 9,300, including lawn seating, and also offers scenic desert views. (Courtesy of Todd Photographic Services.)

Hohokam Stadium was built in 1977 and then replaced for the 1997 season. The facility honors baseball as well as state history. Its name is taken from the name of the state's earliest residents, the Hohokam Indians, and the field is dedicated to Dwight Patterson, the "Father of the Cactus League." The longtime home of the Chicago Cubs, the stadium is known as much for its action on the field as it is for fans' tailgating and fun outside. (Courtesy of Todd Photographic Services.)

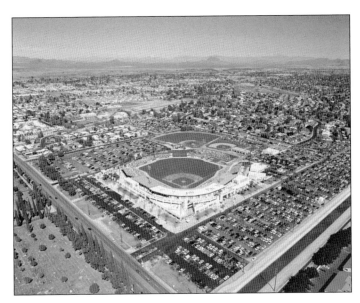

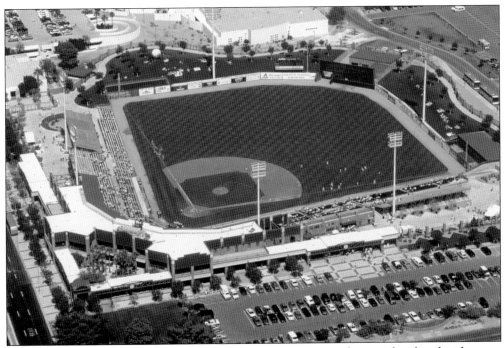

Scottsdale Stadium first debuted for the 1956 season; it was torn down and replaced with a new facility for the 1992 season. The city launched a renovation in 2005, and the stadium today is a league favorite thanks to the World Champion San Francisco Giants and the "see and be seen" atmosphere. In 2011, the stadium averaged about 10,000 fans at each game. (Photograph by *East Valley Tribune*; courtesy of Mesa Historical Museum.)

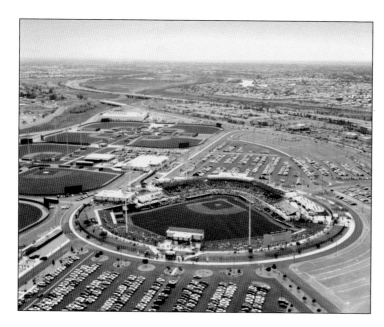

Opened in 1994, the Peoria Sports Complex is the spring training home of the San Diego Padres and Seattle Mariners. The complex, the first two-team facility built in the country, sprawls over acres and offers a stadium seating more than 11,000 fans. (Courtesy of Todd Photographic Services.)

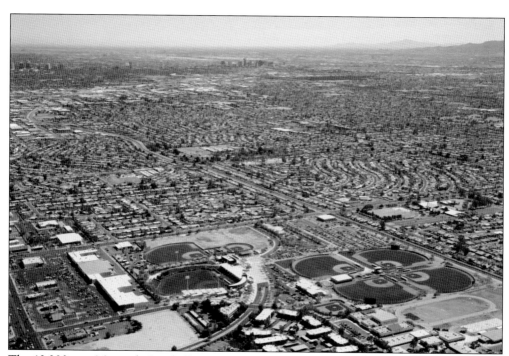

The 10,000-seat Maryvale Baseball Park in Phoenix opened in 1998 and lured the Milwaukee Brewers from the team's spring training home in Chandler. Fans at the intimate stadium are prone to stake out lawn seating, which stretches the length of the entire outfield. The area offers plenty of room to spread out and also great game views. (Courtesy of Todd Photographic Services.)

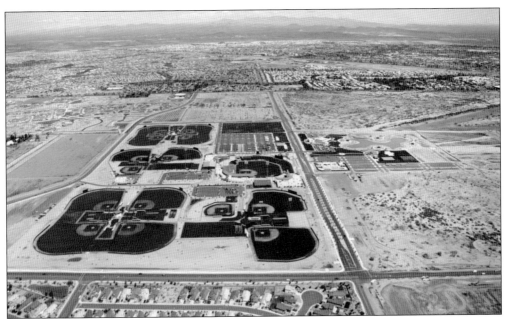

Surprise Stadium, which opened in 2002, hosts the Kansas City Royals and Texas Rangers. The stadium offers amenities like specialty concession stands and a party deck, and sits inside a 124-acre site. In 2004, the stadium was named "Best place to watch a spring training game" by the *Phoenix New Times* newspaper. (Courtesy of Todd Photographic Services.)

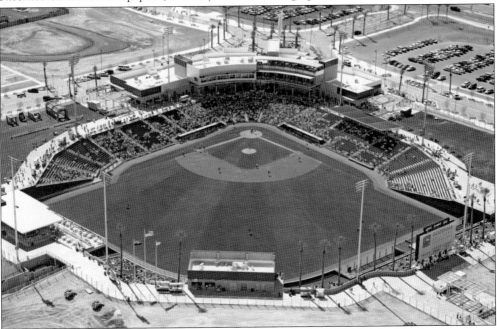

Goodyear Ballpark opened for the 2009 season, bringing the Cleveland Indians back to the Cactus League. The Cincinnatti Reds followed in 2010. The stadium offers traditional seating but also a larger area for lawn seats, special suites, and a "party deck." Beyond the action on the field, fans can take in picturesque mountain views and check out a towering baseball-themed sculpture. (Courtesy of Todd Photographic Services.)

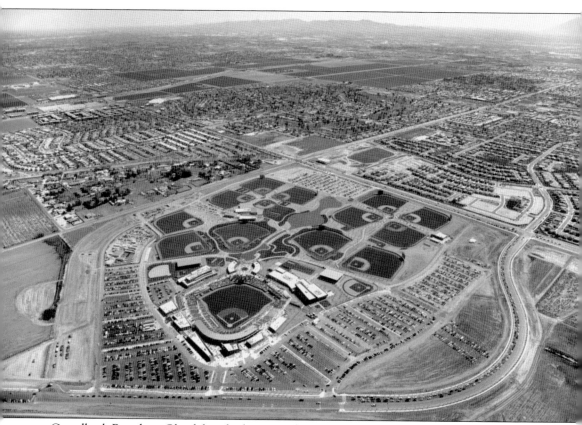

Camelback Ranch in Glendale, which is spread out over 141 acres, is the home of the Chicago White Sox and Los Angeles Dodgers. Opened in 2009, the stadium boasts 13,000 seats and has drawn record-setting crowds. In addition to baseball, fans at the complex can stroll along walking paths or check out a fully-stocked lake. (Courtesy of Todd Photographic Services.)

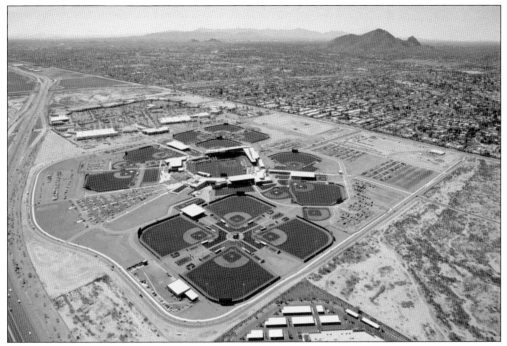

The Cactus League's newest stadium, Salt River Fields at Talking Stick near Scottsdale, hosted its first spring training in 2011. The 140-acre complex is the home of the Arizona Diamondbacks and Colorado Rockies, both of whom left their Tucson training bases for one closer to other teams. Salt River Fields is owned by the Salt River Pima-Maricopa Indian Community and is the first major-league spring training stadium built on tribal land. The unique partnership led to the ballpark's theme, "Two Teams, Two Tribes, One Home." (Both, courtesy of Todd Photographic Services.)

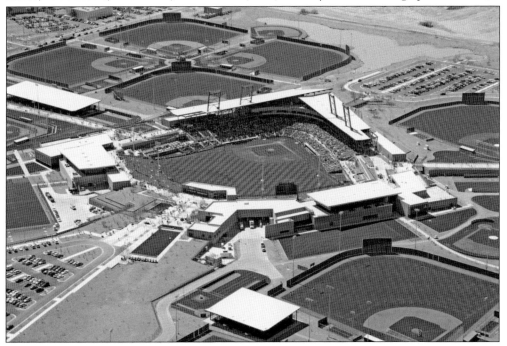

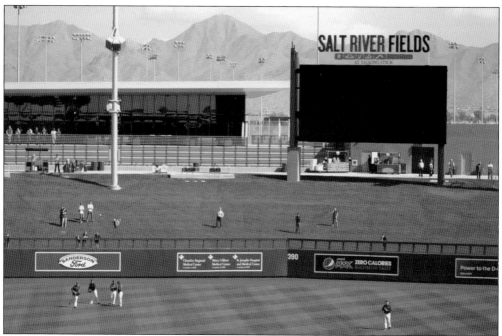

Fans flocked to Salt River Fields for the stadium's inaugural season. Not even the 2010 World Champion San Francisco Giants and perennially popular Chicago Cubs could top the new stadium's attendance. The Arizona Diamondbacks drew an average of 11,100 fans per game, while the Colorado Rockies saw about 10,500 fans per game. The attendance was almost double what each team saw the previous year in Tucson, according to the Cactus League. (Both photographs by *The Arizona Republic*.)

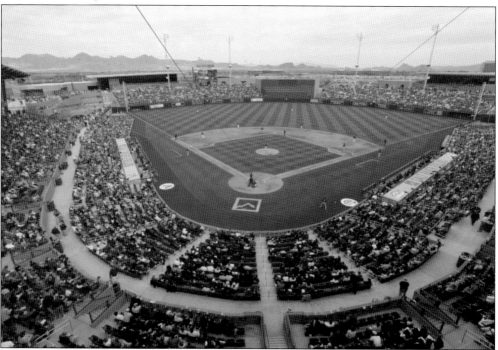

About the Organization

This book is a result of collaboration with the Mesa Historical Museum, a nonprofit museum incorporated in 1966. The museum has long contributed to the exploration and preservation of the heritage of the Phoenix Metro area and since 2008, has developed the new Play Ball: The Cactus League Experience program. Play Ball explores the rich heritage and impacts of spring training on our communities throughout the state. Opening in the Lehi campus of the Mesa Historical Museum with just 1,000 square feet and 100 objects, the museum now boasts several exhibits in multiple locations with a collection of more than 2,000 baseball photographs and objects from spring training. This one-of-a-kind collection covers the earliest days of baseball in Arizona and represents the full history of the Cactus League from its 1954 beginning through today. The museum has collected images and objects that explore every facet of the spring training experience. Baseball teams, baseball fans, and other museums have contributed to the growth of the collection, which is expected to eventually become part of a permanent museum. The museum's collections are on display at a variety of places throughout the Phoenix area, and information can be found at www.playballexperience.com.

Discover Thousands of Local History Books Featuring Millions of Vintage Images

Arcadia Publishing, the leading local history publisher in the United States, is committed to making history accessible and meaningful through publishing books that celebrate and preserve the heritage of America's people and places.

Find more books like this at
www.arcadiapublishing.com

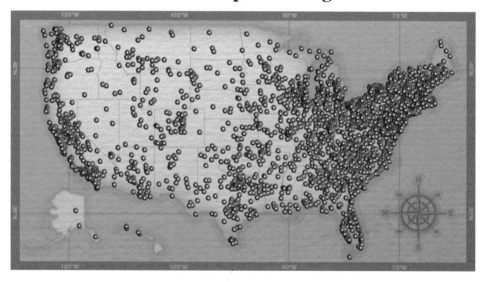

Search for your hometown history, your old stomping grounds, and even your favorite sports team.

Consistent with our mission to preserve history on a local level, this book was printed in South Carolina on American-made paper and manufactured entirely in the United States. Products carrying the accredited Forest Stewardship Council (FSC) label are printed on 100 percent FSC-certified paper.